HAUNTED ROCHESTER

Haunted History Ghost Walks Inc.

HAUNTED ROCHESTER

A SUPERNATURAL HISTORY OF THE LOWER GENESEE

MASON WINFIELD
WITH JOHN KOERNER, REVEREND TIM SHAW AND ROB LOCKHART

HAUNTED
AMERICA

Published by Haunted America
A Division of The History Press
Charleston, SC 29403
www.historypress.net

First published 2008
Second printing 2009
Third printing 2009
Fourth printing 2011

Manufactured in the United States.

ISBN 978.1.59629.418.9

Library of Congress Cataloging-in-Publication Data
Haunted Rochester : the supernatural history of the Lower Genesee / Mason
Winfield [et al.].
p. cm.
ISBN 978-1-59629-418-9
1. Ghosts--New York (State)--Rochester. 2. Haunted places--New York (State)--
Rochester. I. Winfield, Mason.
BF1472.U6H384 2008
133.109747'89--dc22
2008013312

CONTENTS

Contents

PREFACE

W e did not make up anything in this book, so someone else deserves credit for everything it holds. When dealing with a nonacademic subject like ghosts, a complete listing of literary sources and inspirations would be both exhaustive and pretentious. We will mention only the most prominent. A listing of the individuals we interviewed would be outright unfair to those who talked to us confidentially.

A heavy portion of the material in the first three chapters of this book can be found somewhere in the research books of Mason Winfield: *Shadows of the Western Door* (1997), *Spirits of the Great Hill* (2001), *Haunted Places of Western New York* (2003) and *Village Ghosts of Western New York* (2006), all published by the Buffalo-based company Western New York Wares. Readers hoping for a broader look at regional hauntings are encouraged to turn to them and their listed sources.

Most of our non-paranormal information about sites and events comes from city, county and regional histories and a variety of websites on Rochester's history, culture and architecture. One that stands out is that of the Rochester-based Landmark Society of Western New York.

Our Native American insights come largely from the reflections of the missionaries nicknamed the "Jesuit Relations," Bishop Seaver's *Autobiography of Mary Jemison*, unpublished material of Mason Winfield, interviews with the late J. Sheldon Fisher and decades of conversations with any local Native American folk who would talk to us. Those on the record include the Algonkian teacher Michael Bastine, Seneca "wise woman" Jean Taradena and Mason's late friends, the Seneca storyteller DuWayne "Duce" Bowen and the Tuscarora author and medicine man Ted Williams.

A half century of articles in the *Rochester Democrat and Chronicle* have to be credited generally, as well as *Valley of the Ghosts*, Shirley Cox Husted's 1982 gathering of Genesee Valley tradition. Both sources could be credited fifty times in this book. Frederick Stonehouse's collections of

Great Lakes lore and the books of Hudson Valley author David Pitkin contributed leads and nuggets to many of our articles, as did national paranormal surveys by Janet and Colin Bord, Mary Ellen Guiley, Dennis William Hauck and Salvatore Michael Trento.

Our fourth chapter would not have been complete without the unique insights and connections of John Koerner. Most of the work of the last two chapters was the original research and perseverance of Rob Lockhart and Reverend Tim Shaw. They identified sites, obtained research material and interviewed individuals.

Finally, our literary forefathers in upstate history and prodigy, Carl Carmer and Arch Merrill, have to be paid tribute. The sense of tradition they gave made the area seem venerable even when it was young. They did a lot to make the valley see itself as it deserves to be seen.

YOUNG LION OF THE WEST

Old Ebenezer Allan, he
Harnessed the raging Genesee,
And hitched it to a big grist mill
Before our city was a ville.
—Thomas Thackeray Swinburne

This is a book about psychic traditions, incidents and folklore in the lower Genesee Valley around Rochester, including those spontaneous apparitions we call ghosts. Psychic folklore is everywhere, of course, but this part of the upstate has been proverbial for occultism and spirit talking since the whites arrived.

The lower Genesee is at the core of the "Burned-over District," and the nineteenth-century flowering of its many cults, creeds and communities was one of the more remarkable developments in United States social history. A distinguishing feature of these young religions—among which were the Church of Mormon and Spiritualism—was their use of practices upon which the mainstream cast a cold eye: crystals, geomancy and spirit talking. Otherwise, the psychic bedrock of the valley has to be thought of as Seneca, in whose culture there was no shortage of supernaturalism. A little grounding in general history may serve us well.

The landscape is young in this part of the Great Lakes, only fifteen thousand or so years old. The glaciers, as they advanced, etched and retreated, created most of the lakes, hills and valleys that mark the region. By about 8000 BC, the climate was hospitable enough for people to settle here for good.

The north-flowing Genesee River bolts through the heart of the Onondaga Escarpment, the flinty bread loaf running through the Iroquois homeland. The stone not only makes a great projectile point, but it is also easily mined in many parts of Western New York, influencing (with water routes) the region's human prehistory.

As far as anyone knows, the first people in these parts were Paleo-Indians—the earliest Native Americans—who might have included the ancestors of today's Eskimos. Ancient Native American societies, influenced by mound-building cultures, dominated the region by 2000 BC, and in the European Middle Ages, communities of Algonkians were here. There are tantalizing suggestions of other visitors and immigrants to this part of the valley, including Scandinavian Vikings and mystery societies no one recognizes.

By the time the Europeans were exploring the Great Lakes, the Genesee ("Beautiful River") Valley was settled by the Senecas. Many of today's towns are on the sites of the culture centers of the *Nundawaono* ("Great Hill Folk"), as they called themselves. Their paths have become many of our roads, particularly ones with numbers: Routes 5, 96 and 104. Rochester sits atop their old villages.

The first known white man to see the mouth of the Genesee River was Etienne Brule, a French outdoorsman sent by Samuel de Champlain to survey the Great Lakes in 1610. The map Brule drew seems to show Irondequoit Bay and the Genesee River. The next visitors might have been Jesuit missionaries in 1635 and French explorer René-Robert de La Salle in 1669.

For a region so far from the coast, greater Rochester has a lot of colonial-era sites. By 1679, the first Euro-style church was raised near Irondequoit Bay on the spot of today's Our Lady of Mercy High School. In 1687, the French built a short-lived fort nearby. In 1716 and 1721, the French and English built, respectively, Fort DeSables by today's Sea Breeze and Fort Schuyler at Indian Landing.

Not until the mid-1700s did the valley fall officially under the ownership of the English. Only a few traders and trappers ever saw it. It was during the 1779 revolutionary campaign of U.S. General John Sullivan that many Yankees got a look at the splendor of the land they were devastating. The Treaty of Canandaigua gave the land to them by the century's end. White settlement of Western New York was an avalanche after 1800.

Water has always had a lot to do with political and economic power in North America, and it explains the location of most forts and trading posts. When Europeans started settling here in earnest, water had another use: physical power. It turned mills, ground grain and sawed lumber, and there are strong creeks and falls aplenty along the Genesee River. One of the early discouragements of settlement was malaria, a mosquito-born disease also associated with water. The swampy land around the lower Genesee Valley was also a playground for rattlesnakes. No one envisioned a major city here.

Young Lion of the West

In 1803, three Revolutionary War buddies from Pennsylvania—Major Charles Carroll and Colonels William Fitzhugh and Nathaniel Rochester—bought Ebenezer "Indian" Allan's hundred-acre milling operation in what would be today's Rochester, west of the Genesee River near the Court Street Bridge. The success of their enterprise and the surrounding community was due to the river's gift of turning gristmills and ferrying flour off for sale. Transportation routes that came later kept the community called "the Flour City" thriving, and its product was of high quality. Queen Victoria insisted on Rochester flour for the Buckingham Palace kitchens.

At its 1834 christening, Rochester held 9,200 souls and was soon the largest flour producer in the United States. "The Young Lion of the West" was the first American boomtown, doubling its population every fifteen years for the rest of the century. By 1900, the head count was 162,000, and this city with a penchant for nicknames became "the Flower City," probably because it made for prettier postcards.

Rochester bloomed with more than financial prosperity; it grew ideas, and not just the mystical ones associated with the Burned-over District. Many were progressive and political views that we consider fundamental today, like the abolition of slavery and women's rights. In some senses, Rochester was the region's social conscience.

This same progressiveness in practical venues may have kept Rochester growing through the first half of the 1900s. The garment and automobile industries were beneficial, but it was the early technological revolution that made the greatest difference. Optics (Bausch and Lomb), cameras (Eastman-Kodak) and copiers (Xerox) led to a new renaissance of major industries and helped white-collar Rochester avoid the depression of other Great Lakes and "Rust Belt" cities. Of course, a new nickname arose: "the Image Center of the World." Once Rochester's colleges and universities started their notable partnerships with corporations, the deal was done.

Rochester today is a cultured city that boasts much classic architecture, about which—even in a ghost book—a word needs to be said. It has been stated that four men—the Warners, father and son, Harvey Ellis and Claude Bragdon—designed most of the great work in the downtown area. Other worthy names arise, including those of the earlier father-and-son team, the Searles. The "classic" architecture in this region tends to attract ghost stories. This is not the book to conjecture why.

But a sign of the immense hope and inspiration that built Rochester may be found in its evocative skyline. This magnificent "skyscape" features some of the most original structures—the fishtail fans of the Times Square building, a soaring Mercury—that you will ever see, and after seeing

them, you will never forget them. So many of Rochester's leaders felt the need to give back to the community. The tradition of philanthropy and civic awareness is so strong that one wonders if the Genesee River feeds it like an artery into a heart. It is little wonder that so many who live in the Senecas' "Sweet River Valley" never want to leave.

NATIVE SPIRITS

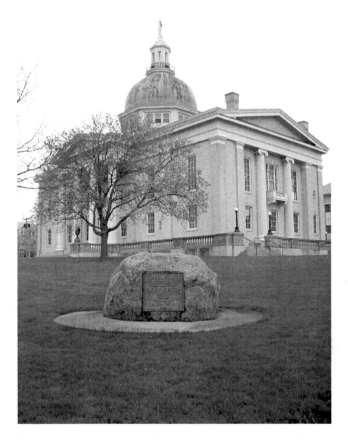

Treaty Rock rests near the Ontario County Courthouse. Some
believe the spirits of the valley Senecas are resting here as well.

OLD GENESEE ANCESTORS

G hosts and Revenants, Memory, History, and Folklore" was the theme of the 2007 World Fantasy Convention in Saratoga Springs, New York. A guest of honor and featured speaker was Abenaki author and publisher Joseph Bruchac, who told ghost stories of the native Northeast. The Abenaki are not even linguistic cousins of the Iroquois nations, but they come from the same region as the easternmost Mohawks.

Someone summarized the tone of the evening as a lot of tales about "skeletons" and "cannibals." Most Native Americans of the Northeast, including the Iroquois, believe in ghosts, and they know the haunted places in their current and former territories. But they don't develop stories of the European style. The creepiest aspects of their folklore feature supernaturally powerful human eaters and corpses reanimated into forms that might in other traditions be labeled revenants, ghouls, zombies and vampires.

Even today, the Iroquois attitude toward ghosts is different from that of most other Americans. Many Iroquois have a strong faith in presences that we might call spirits—of the human dead or otherwise. But these are not ghosts—apparitions. They are invisible. They could quite well be gods, Little People (the Iroquois fairies), animal spirits, acts of magic, the powers of fate or entities of other sorts that were never incarnated. Most Iroquois reports of ghosts imply that they are some leftover of the human personality, as if the *orenda* ("life force") that filled people when they lived might occasionally congeal and re-project their image in some environment that was once natural to them. This makes a lot of sense when you go by the reports of witnesses worldwide. But no Iroquois I know would put it that way.

Ghost sightings happen so frequently on reservations that the residents hardly notice them. They're amused by the terror of whites. Another type of apparition, a clearly psychic image projected by a dangerous site or a human medicine person, can trouble reservation folk beyond words. Some whites, to their misery, have had encounters with these sorts of things.

This image, however, is not a ghost. If it is valid, it might be an example of what today's Iroquois call *medicine*, and the rest of us call *magic*. It is either, in extreme shorthand, a projection of world magic (*orenda*) or human magic (*otkon*). Whatever it really is that white people encounter at these sites, they usually just report it as "ghosts."

We have pieced together some psychic events and stories related to the Genesee Valley's first inhabitants. It is only right if you feel them in this book. You walk this valley with them.

POWER PLACES

The classical world believed in two kinds of sacred places: ones people made holy through architecture and devotion, and ones the gods designated through their natural works of fountains, falls, faults and other fey places. The mightiest, of course, are ones that are both—human shrines at geophysical power spots.

The Genesee Valley had plenty of monuments and markers sacred to ancient societies. Some were mysterious even to the Senecas. The only ones we can write about are those prominent enough to the first whites to be listed in the histories. Wherever these sites are, they are magnets for psychic folklore.

Rochester holds three falls along the Genesee River. These were general mystery spots to the Senecas, who considered them, like other strange or spectacular natural places, special to "the Little People," the fairies called *Djogao* and nicknamed today "the Jungies." We don't expect to learn much beyond that. Traditions about the Little People are the most private that the Iroquois have. Fairy sites in Europe were associated with other aspects of psychic folklore: witchcraft, monsters, giants, mystery lights, treasure and ghosts.

Seneca trails underlie some Rochester streets. Four big Seneca towns were nearby. One, in today's Victor, would have been *Gannogaro* (flexibly spelled). *Gandougarie* (with the reputation of a prison camp) was in East Bloomfield, *Totiakton* was in Rochester Junction or near Mendon and *Gannounata* was around Lime and Avon.

Old Native American power sites were often near major trails and were geologically distinct. City planners delight in destroying them as much as they enjoy demolishing architectural treasures of white society. The Cold Spring in Buffalo is one such site, now buried beneath apartments at Main and Ferry Streets. Another is a spring along the same trail, today's Route 5, by "the Place of the Great Hearing" in Batavia, now under an

auto shop. Both sites catch a bit of folklore. It seems as if radiant energy spirals above them, drawing ambivalent psychic experience out of the twenty-first-century people who tenant or frequent the sites. Doubtless, there are dowsers and mystics who could explain this to us.

At the corner of East Avenue and Council Rock in Rochester is a weathered limestone boulder with a lot of history. Orringh Stone's tavern was located around here, but long before it did business, Council Rock, flanked by an enormous elm, was the meeting place for the valley Senecas. So many important decisions were made there by the Senecas, and who knows how many nations before them—Denonville's invasion, Sullivan's march, the treaties, the relocation.

East Avenue was widened in 1904. Council Rock was preserved. The state historical association put a tablet on it in 1919. When East Avenue was widened again in 1931, the rock was moved twenty feet north. If you were to draw a circle a hundred feet around the imaginary former site, it would include the current location of the stone. A few homes and spaces in that circle get psychic reports today, but none we've heard have been of the "spectral Native American council" variety. Ghosts are the flowers of psychic energy at a site. We should not decide in advance what to expect, and we should not be surprised by what we get.

THE LEGEND OF LONG POND

A young Seneca couple journeyed along Lake Ontario to join their families on the Niagara River. They camped near Long Pond in today's Greece and met a handful of fellow travelers.

The Genesee Valley could be lawless in pre-Revolutionary days. The travelers were a party of white renegades. At first they shared fire and conversation, and then they cast admiring eyes on the fair young woman. They drew closer to her and stopped addressing the husband. Soon, one started going through the few belongings of the couple, looking for anything of value. Others started pawing the wife and told the husband to scram. They either didn't know he was Seneca or didn't know the Senecas at all.

The young man drew the only weapon near him—his knife—and fell on them instantly. His wife ran into the darkness. One renegade who turned to follow her took a mortal wound. It was clear that any who turned to chase her would share his fate as long as her husband lived. He dealt at least one more deathblow and wounded many. But the white men had numbers, clubs and tomahawks. The young Seneca man suffered many wounds and at last dove into the pond. Somewhere near the center, he went under, singing his death song.

All was still, and the whites stood with their guilt in the firelight. Suddenly, from an invisible grove, they heard the woman's voice, chanting bitterly. None needed to know Seneca tradition to know that they were being cursed. They never reached their destination. No one knew what became of them—whether they were finished by a party of avenging Senecas or by something less material and far worse.

Ever since, a legend has surrounded Long Pond. The husband's noble form reappears as a sheeny spirit in the center of the waters. Images are common in pools by moonlight, when imaginations are enhanced by darkness. The apparition could be anything, but whatever it is, historian Shirley Cox Husted recalls seeing it.

THE DEERHORN CUPS

A grisly ritual dominates the art of the Moche, a pre-Incan Andean civilization. Their murals show a sacrifice in which a victim's throat was slashed and the first blood was caught by a priestess or goddess in a special cup. Academics speculated that the ceremony could be mythological, perhaps an event from Moche cosmology, but then a cup like the ones in the murals was found in a high-ranking female's grave. The finders still speak of the moment of discovery. The Genesee may have its own version of this ritual. The following is a story we have heard.

One of the old hands in local archaeology was asked if ever, in all of his experience with religious objects and human remains, he had encountered anything that had "creeped him out."

"Just once," he replied.

A freelance archaeologist, a "pothunter," brought the museum something that made his hair stand on end. It was from the grave of a woman in the Genesee Valley. By the artifacts around her bones, he judged that she had been a priestess. Found buried with her were two small cups made from the stem of an antler and a deer bone ground and sharpened into a big hypodermic needle. As he took these objects and held them in the moonlight, a chill took his breath away. The academic who recounted the tale felt something funny himself upon beholding them—"Like my grave was stepped on." There may be an explanation.

Missionaries in the Northeast described a ritual involving a macabre serving set. When some indigenous villages had an important captive and decided to make an example of him, a hierarchy of tormenters went to work. The final figure was a priestess in whose charge was a set of antler cups—two small, delicately carved bone vessels—and an equally fine bone needle, tapered and sharpened. When it was inserted between the ribs of the victim in just the right spot, the heart pumped its sweetest blood directly through the marrow channel and was caught by the antler cups.

This was no Iroquois ritual, and the objects point to a different influence in the Genesee Valley, but imagine the feelings of the first discoverer as he threw the earth off them like a coverlet. How many victims had they claimed?

THE WAILING SPIRIT

T he Genesee Flats" is what the locals called the wide valley made by the Genesee River between Geneseo and Mount Morris. At early dusk in February 1807, a Leicester resident crossed the flats on his way to the western bank. Halfway across, an uncanny wailing filled his ears. Night noises were nothing new in this wild, wooded country, but this sound was humanlike—a wretch in despair and torment. It could have been the howls of the underworld, but coming from the wrong direction. It went on as long as he could stand to hear it in the clear air overhead.

A handful of neighbors came to the spot the next night and heard for themselves the ghastly noise. Word spread, and folks came from all parts of the valley. The crowds grew, sometimes to as many as two thousand people. They were not disappointed.

Humble miracles often became sensations in that undeveloped country. (It was estimated that in 1826, fifteen thousand people watched Buffalo's last public execution.) No wonder they kept coming to hear this wailing spirit. The miracle was that it was dependable. Like clockwork, it sounded off at twilight for two consecutive weeks.

A large group of Senecas lived at nearby Squakie Hill, and many of them had observed the marvel. A council was called. A chief's father had recently died, and it seemed likely that this was his disoriented soul. It had lost its way to the land of the Creator, and, caught in a frightful netherworld, its cries were calls for help.

A hundred warriors waited beneath the sound and fired their guns in unison into the air. When the echoes faded, the gusty shrieking was no more. The sounds were not reported again after the Seneca ceremony, so perhaps their explanation had some truth to it.

TWO-TIME CAIN

Squakie Hill is a ridge at the northern end of Letchworth Park. Seneca villages and prehistoric Algonkian communities were located here. Earthworks and stone ruins found in this area are signs of civilizations before them. *Squakie* could be an Anglicization of a number of Native American terms, including the name of the nation the Seneca blamed for bringing witchcraft among them. A sign of the hill's sacredness, this was the site of the last "White Dog" ceremony to be held in the valley. No wonder karma loomed here, and an angry spirit had the force of place to hold it.

A frontier hero of the War of 1812 was the Seneca chief they called Young King. The war had barely ended when he had some kind of fight with the government blacksmith at Buffalo. A blow from a scythe cost him an arm and caused outrage among the Senecas. As they pursued their legal options, one of the Great Hill folks stomped off to Buffalo.

John Jemison was the son of the "White Woman of the Genesee," Mary Jemison (1743–1833), and the fearsome chief Hiokatoo. Orsamus Turner saw the self-appointed executioner on his way to Buffalo, decked with paint and horsehair and carrying traditional weapons. To the author of *History of the Holland Purchase*, he looked like "the Angel of Death." The blacksmith stayed out of sight until things cooled, but Jemison may have been more than a hothead. His own people believed he was a witch.

Rochester's unofficial founder, Ebenezer Allan, spotted something troubling in John Jemison as a boy, and Allan, a first-rate frontier scumbag himself, ought to have been able to tell. Something happened in Jemison's boyhood that gave his brother, Thomas, the idea that he was a witch. From that point on, the rumor stuck.

Witch or not, Jemison was known as a healer all through the valley. On long nightly forays in the woods, he gathered herbs for his spells, potions and poultices. He was also a seer, whose dreams and visions told truth.

He foresaw many deaths, including his own. Some he also caused. The killer of two brothers, he was twice a Cain.

Early in July 1811, Thomas Jemison came to his mother's Genesee Valley home a bit the worse for drink. There, he found his witchy brother. Their quarrel ended only when John Jemison dragged Thomas outside by the hair and killed him with a tomahawk. His mother found Thomas on her doorstep. The Seneca council concluded that this was a simple fight, for which neither party was to blame.

Mary Jemison had another son, twenty-eight-year-old Jesse. She relied on him after the death of her husband and ordered Jesse to steer clear of his brother John.

One May morning in 1812, Robert Whaley of Castile hired a crew to help him move lumber. It included both Jemison brothers. At the end of the day, John Barleycorn came calling, and a fight broke out. Witch-warrior John Jemison pulled out a knife. His younger brother tried to take it away. Any one of Jesse Jamison's eighteen wounds could have been fatal. There were no legal consequences in this case either, as it probably seemed like no more than a drunken knife fight. But John was a pariah—until people needed magic. In the spring of 1817, he was called to Buffalo as a healer.

A few weeks later, Jemison was partying again with several Senecas on Squakie Hill. A quarrel started, and two men history remembers as Doctor and Jack decided to kill him. Pretending to be friendly until the party broke up, they hauled Jemison off his horse, hit him with a rock and finished him with an axe. He was fifty-four.

Iroquois society was no stranger to duels and feuds. It also had reasonable laws, and this was premeditated murder. But blood didn't have to have blood if a killer sent an offering to a victim's family and it was accepted. Usually this gift was white wampum, a beaded sash holding the Confederacy's symbol, the two squares–diamond–two squares configuration called "Hiawatha's Belt." The murderers tried this with Mary Jemison. She refused the gift and advised them to run before the council met. This they did, escorted by their relatives. At the border of Seneca country, they faltered. They couldn't leave their families, their villages, this valley. Their uncle Tall Chief advised them to face the council, say their goodbyes and take their punishment "like good Indians [*sic*]."

Jack snarled and even threatened his life. The old man raised his voice:

> *If you go into the woods to live alone, the ghost of John Jemison will follow you, crying, "Blood! Blood!" and will give you no peace! If you go to the land of your nation, there that ghost will*

attend you, and say to your relatives, "See my murderers!" If you plant, it will blast your corn; if you hunt, it will scare your game; and when you are asleep, its groans, and the sight of an avenging tomahawk, will awake you!

They ended up wandering, despised and despising each other and their own lives, which they ended apart on Squakie Hill. One poisoned himself, and the other shot himself soon after. Jemison's revenge had come.

The Senecas always thought Squakie Hill was haunted by the witch and his murderers' ghosts. Does Jemison's influence linger? Shaman, trickster, is it you at your shape-shifting, behind the troubling dreams of campers, the gnarling of the trees, the shadows along the trails, the howls and cries? Do you toy with your killers still?

THE CURSE OF THE BONES

The old-timers among the upstate Iroquois believed in the power of curses, both those directed by living power people and those that lingered at certain sites. It may be hard for the reader to understand this belief system, but many people living in Western New York—and not just Native Americans—have their reasons for leaving it an open question. There is a story circulating that began, take your choice, during the Ice Ages, in 2000 BC or in 1998. It has a psychic component.

The Onondaga shelf can be porous or flinty-hard. The Genesee River cutting through it branches off in many a vein. All that running water has left a lot of minerals underground.

In 1885, a shaft was sunk nine hundred feet to a layer of rock salt. A century later, the Retsof Mine was the largest in North America. The size of Manhattan, it covered ten square miles underground.

In 1994, part of the mine collapsed and flooded. Then-operator Akzo-Nobel gave up on it. The state lost a lot of mining and trucking jobs, and Livingston County lost its second biggest taxpayer. In January 1997, a new outfit, American Rock Salt, set up to tap the mine from a different direction. The nation's first new salt mine in forty years was a high profile, feel-good endeavor. For twenty-four hours a day, seven days a week, work progressed on a three-mile spur connecting the mine and the railroad.

Not everyone was happy. Environmental protests were largely ceremonial, but Native American burials found at Hampton's Corners upped the ante considerably. The Native American Graves Repatriation Act (NAGPRA) had real teeth by then and its bite was big enough to imperil even non-Amerindian burials, like Washington State's "Kennewick Man," and freeze the understanding of ancient America at its current state. Stopping a salt mine was effortless. Native American groups, either living ancestors or "cultural affiliates" of the dead, had to be found to consent to the handling of the remains.

"The suits," of course, just wanted work to go on. At first sight, the matter didn't look complicated. Some burials were clearly those of Senecas from the Contact Period. Many Senecas still live upstate. Talking turkey with them happens all the time.

But the ground also held Blackfoot and Algonkian folks whose cultures haven't lived in the region since the time of the Crusades. They were not members of the Iroquois Confederacy, spoke non-Iroquoian languages, held different customs and beliefs and could have been put in their graves by the Iroquois. Finding their representatives wasn't going to be easy.

The new salt mine site turned out to be a prehistoric power point: the meeting place of ancient trails, home to a village or two and a multicultural burial ground dating from 2000 BC and maybe earlier. The immediate study found a potential tumulus or burial mound. A ceremonial earthwork, famous enough to be called "the Viper Mound," had been paved over in the mid-1970s by I-390. Rail lines, mine shafts and parking lots would destroy it all. This was a new kettle of fish.

"Mound-building" societies like the Hopewell and Adena are mysterious. We know them only from burials, artifacts and the massive and symbolic earthworks that so mystified the Senecas when they came to this valley. It is hard to identify their living ancestors. Who rules on their remains? NAGPRA, we have a problem. Enter, according to the story, a prominent Seneca.

This gentleman devoted his life to teaching the world about his Seneca ancestors. The government sensibly turned to him in matters like this. Some of his decisions have been controversial. The way some tell it, artifacts, remains and even the piles of GOK ("God Only Knows") from the salt mines fell largely into his lap. The bones, every last nub of them—in theory—were relocated to nearby portions of the property or elsewhere in the valley. The mine opened in due course.

Protests came in from Native Americans who were not included in the decision. "He makes the deal, he takes the money, he does…*what* with the pots and bones?" said one. "Do they go into his museum? Does he sell 'em? They aren't his ancestors. They're mine!" Talk of backroom deals, political intrigue and payola ran amok. White activists, alas, may have been shouting the loudest.

Other Native Americans were understanding. "What would you have done with those bones?" said the late Tuscarora author and medicine man Ted Williams, a longtime Brighton resident and Kodak employee.

You go to some reservations, you can't find anybody to talk to. Some of these nations don't even have chiefs. Some of these decisions are gonna make nobody happy, but they gotta get made.

Ted had a point. The embassy of the French is easier to find than that of the Olmec.

But Ted wasn't there for what others claimed to see: the heaps of dirt containing grave goods, even pieces of human bone, piled along the construction site as if by a bulldozer. Surely some justice awaited this desecration. There was talk of curses and mine disasters. Suicide, death, substance abuse, madness and ruin plagued local politicians. Even passersby suffered. One who took an artifact lost a leg in an accident. Another touched a piece of skull and found her mother dead at home. Mystery lights and "altered animal" forms were reported. Auto accidents were common on nearby stretches of Routes 5 and 20. It would be interesting to know what the late motorists saw before spinning out of control.

When the matter of the mine and the curse was hottest, a prominent elder visited the region. He was of the Onondaga, which was thought to be the oldest and most traditional of the Iroquois nations. He gathered members of the native community. "This is battlefield as well as burying ground," he said. "Ask permission if you have to pass through."

He showed people the troubled areas and told them to keep children away after dark. "Kids are vulnerable. They'll see things the parents won't." He worked a ceremony to ease the spirits and minimize harm to the living innocent. Then he headed up to Rochester.

He interrupted our Seneca friend in his office as he was toiling with a block of stone imbedded with bones and artifacts. Without saying a word, the old healer took one troublesome femur up like a piece from a jigsaw puzzle. It leaped into his hand as if a spirit had been holding it and just then decided to let it go. Then he put it back. The Seneca went to pull it out again and found it stuck. Like the sword of Arthur, it decided who could extract it.

The Onondaga man wagged his finger.

> It's all about the intent. If your intent is for the good of the world, a lot of these problems will go away for you. If you're selfish... the Old Ones will know it. And they'll never get out of your way.

THE GHOSTS OF WAR

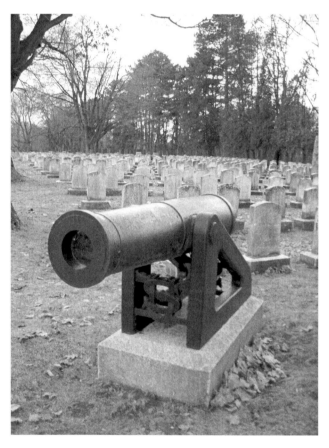

War relics in the Genesee River Valley tell the unimaginable
stories of much historic bloodshed.

THE LORE OF WAR

Though the region at the mouth of the Genesee River saw activity in all the colonial wars, it is no wonder that its martial reputation is overlooked. No *Last of the Mohicans*, in print or film, commemorates it. Only in one war was the most consistent fighting and dying concentrated in Western New York, and the War of 1812 is called "the forgotten conflict." The Genesee Valley saw movements of soldiers, of course, and a few naval clashes, many of them head butts that barely made it into the books. But there were earlier colonial battles and even prehistoric run-ins. One such is Sweden's nasty Alhart site, which holds more than a dozen bodiless skulls. Other skirmish spots and battlefields under us may never be discovered. One would expect ghost stories to gather and no one ever to know why.

Rob Lockhart, John Koerner and I have just finished writing a book on psychic folklore at War of 1812 clash sites on the Niagara River. We found something interesting: battlefields attract ghost stories, as you would expect, but when it's a well-publicized fort or battleground, people report the ghostly forms they expect to find. They could be purely imaginary. People who don't know they're on a battlefield see ghosts, too, but these ghostly forms are more generic and current. It is as if something is at work, making people see things—like the very ground has been energized.

GANONDAGAN

Today, the spot of the ancient Seneca village *Gannagaro* is a state historic site in Victor called *Ganondagan*. An educational park with displays and replica buildings, Ganondagan is a monument to pre-Columbian Seneca life. This site on Victor-Holcomb Road is thought of as a spiritual center located on some source of mystical power. Without question, the Iroquois and their upstate forbears have vision sites worth commemorating. Ganondagan is…complex.

In the legacy of our species, the idea of a willing union of distinct cultural bodies is a young one. The preindustrial world's concept of unity was usually ethnic or religious. Political leagues were somebody's empire, always spoiling to break back to their original conditions. The first happy union in the world was the grand League of the New York Iroquois, probably a model for the United States. The visionary figures at the founding of this Confederacy—Peacemaker, Hiawatha, "the Mother of Nations"—are legendary and sacred to the Iroquois, as they should be to every American. Gannagaro could have some connection to all three.

Gannagaro was one of the major villages in the traditional Seneca homeland of the Genesee Valley. It is associated in some minds with one of the homes of "the Mother of Nations," the peace queen of a pre-Columbian United Nations. Her support would have been vital to the semi-godly Peacemaker and the prophetic Hiawatha. Some think of Gannagaro as a political shrine, "the Athens of America."

But in the Iroquois mind, there was no extracting one aspect of life from another, including the political from the spiritual. The former village was a power site of national significance and a major shrine today. A lot of its white guests would agree.

A reverence for Native American spirituality permeates the alternative/New Age community. Ganondagan touches non-native folk so strongly that it is a phenomenon in itself. In one literary assessment, "This place

sizzles." People stumble back to lodge or lot, incoherent after hikes about the ridge, reporting experiences in all the senses: visions of ancient scenes and rituals; sounds of otherworldly chanting and drumming; touches from invisible hands and implements; and wafts of sourceless sage and cedar smoke they can smell and taste. Even shaman-style sessions with totem animals and spirits of tobacco and corn are reported. It would probably interest many of today's neo-shamans that their vortex is on or very near a battlefield. As a trauma site, Gannagaro enters our study.

In the late 1600s, the French and English struggled over North America. The conflict was territorial and economic—controlling water routes and thus the fur trade. (Europe was a hot market for the bloody skins of our wild animals.) The Senecas may have liked the French they knew well enough, but they found the French king's demands out of bounds. A French governor set out to teach the Great Hill folks a lesson.

That was usually a bad idea, and this one turned out catastrophic. But for the day, the Marquis Denonville had overwhelming force: sixteen hundred Europeans, a thousand Native American allies and four hundred colonials landed at Irondequoit Bay on July 10, 1687, and marched on the possibly fifteen-hundred-year-old Gannagaro.

You can't sneak up on the Senecas in their own woods. The women and children were long gone by the time the armor-clanking detachment reached Gannagaro. The warriors would have been out clouted by this army in an open battle. That didn't mean much to the Senecas when the subject was forest fighting. A clever, savage ambush almost turned the tables, but Denonville's force reached Gannagaro. It destroyed houses, crops and three other deserted villages before heading back to the lake.

The name Ganondagan may have come later. When the Seneca saw Gannagaro the following spring, it had almost gone back to nature. As if the earth apologized, the tender white flower called *trillium* had overrun the site like winter's last patches of snow. "Ganondagan!" ("Light" or "Brightness") the women called to each other. Gannagaro was never rebuilt.

Late Fishers historian J. Sheldon Fisher (1907–2002) once said that every home near the site has a story. Outdoor apparitions are common on the ridge, and many houses report psychic outbreaks. Still, something odd is at work here. Battlefields attract ghost stories, not shamanic visions.

And not all whites have happy reactions to Ganondagan. After one tour, a young girl was plagued by nightmares and several times she woke her family with screams. In her dream, an old-time Native American was climbing the porch beneath her room. He meant no good.

PATRIOT HILL

One of the nation's most sublime burying places is Rochester's Mount Hope Cemetery on the Genesee River; one of the most tormented is at the point where an old trail meets the same river, linking sites and psychic incidents for over two centuries. Welcome to "the Torture Tree."

During the Revolution, Western New York was a hotbed of British, Loyalist and Native American opposition. Multicultural bands of paramilitaries—we call them *terrorists* today—like Butler's Rangers nested at Fort Niagara, allied themselves with Native American war bands and forged out on the colonies. They specialized in civilian attacks. Massacres at sites like Wyoming, Pennsylvania, and Cherry Valley, New York, can be attributed to them and to the empire's native allies, including the Western New York Senecas, who General George Washington resolved to take out of the war. At harvest time in 1779, General John Sullivan and four thousand buddies—a fifth of the U.S. war strength—marched on Seneca country.

After turning the tables of one big bushwhack near Elmira, Sullivan romped along Canandaigua Lake, up the Genesee River and into the Seneca heartland. He thirsted to come to grips with Seneca and Tory armies. All he could catch were villages and orchards. Sullivan tore up as many of these as he could. Countless Senecas starved and froze in the bitter winter of 1779–80. Sullivan's foray hit its westernmost point at the village of Little Beard's Town. At the point where Route 20-A crosses the Genesee River, some of his scouts met with destiny.

As Sullivan's Continental army neared "the Genesee Castle," it mattered quite a bit which side of the river its target was on. Sullivan's map said one thing and his guides said another. Lieutenant Thomas Boyd was ordered to take a handful of men, avoid fighting, and scout it out. He ended up getting two dozen men into reckless scraps. It was no surprise.

Young Boyd was a firebrand, eager for advancement and none too careful about how he got it. At the Battle of Saratoga in 1777, his riflemen

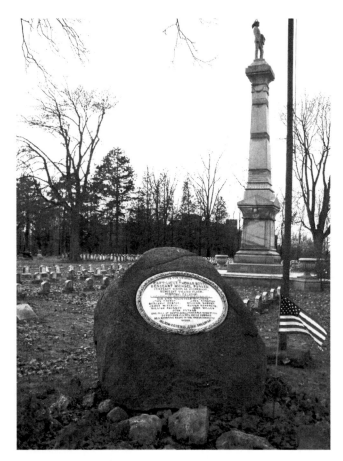

Mount Hope Cemetery is home to this memorial to fallen Patriots killed in the Groveland Ambush of 1779.

turned back a British advance, an act that may have saved the day and the Revolution. A year later, Boyd was again a hero, this time solo. On picket duty, he surprised a couple of men scouting the U.S. Army wagons and brought them in at bayonet point. They were famous Tory desperadoes who were cheerfully hanged for crimes against civilians. Boyd was developing a reputation. He might also have been cursed. As his regiment pulled out of New York, he backed off a young woman he'd wronged with a drawn sword. "I hope you're cut to pieces by Indians [sic]!" she cried."

Against the advice of his Oneida guide, Boyd and his men chased a couple Seneca decoys into a formidable ambush in Groveland on September 14. A handful slugged, slashed and galloped their way out. Boyd and the rest stood their ground and were disabled in gunfire from at least three hundred Seneca, who swarmed in with knife, club and tomahawk. Their mates hacked to dog meat, Boyd and Sergeant Michael Parker were taken to Little Beard's Town for questioning by three Loyalist heavy

hitters: the famous "White Indian," John Butler; the Mohawk Joseph Brant; and Seneca Chief Little Beard, who was doubtless eager to ask why "the Long Blue Snake" (as Sullivan's army appeared to the Senecas from their overlooks) had come to burn his ancestral village. There was only a short time to work on these two. The most was made of it.

General Sullivan himself could hear the ambush and sent cavalry to investigate. By then, most of the Senecas were gone, and the handfuls who reared up and fought were quickly killed. Among the first on the scene was Moses Van Campen, legendary scout, fighter and adventurer. One of the frontier heroes of the Genesee Valley, Van Campen had seen his share of the terrible. To his last day, he admitted that he could not quite forget the sight of the bodies of Boyd and Parker. Possibly to save others the memory, the pair were buried quickly where they were found. Their only memorial was a clump of wild plums, and they lay for decades by Little Beard's Creek where the main trail crossed. Their fellow soldiers rested where they fell at Groveland Hill.

Souvenir hunters knew both spots. Bones, buttons and weapons were routinely uncovered. What stories went with them?

If you think the deaths of the Boyd-Parker mission were tormented, you should track their remains. Life in the Genesee Valley came a long way soon after the Torture Tree. Momentum was gathering to honor all Revolutionary War soldiers lost on valley soil. "Revolutionary Hill," a prominent mound in Mount Hope Cemetery, was designated the spot for reburials. By 1841, the city of Rochester talked the folk of Livingston County into parting with their martyrs.

On August 20, 1841, the remains of the victims of the Boyd-Parker ambush were taken up with ceremony. Descendants of looters showed up to return bits of their grievous spoil. Everything was reinterred days later with fanfare on Revolutionary Hill. Within days, local Democrats accused their political rivals of a coverup. Despite the fact that five thousand people had seen the ceremonies, the charge that the local Whigs had reburied only animal bones caused a controversy that lasted for generations.

The quick cast hungry eyes on the dead as young lion Rochester grew. Revolutionary Hill was prime burying space, and the original wooden monuments were deteriorating. Around the time of the Civil War, Revolutionary Hill was graded to become "Rochester Hill," and the William A. Reynolds family plot in section R was one of the moodiest in

the already atmospheric space. Remains were relocated to "the Common Ground"—Potter's Field, a home for the poor and neglected. That alone may have riled the spirits.

Decades later, "the Young Lion of the West" was undergoing another transformation. Cultural and historic awareness was building again, and these men were no longer out of style, but also out of history. Mount Hope Cemetery donated land and the Irondequoit Chapter of the Daughters of the American Revolution started a search for the graves. It took five years. The day after Halloween 1903, the remains of Boyd, Parker and all other Revolutionary soldiers were moved to the ground they occupy now—a newer, flatter portion of Mount Hope. May Patriot Hill be their last resting place, and may the sleeping be sweet.

Dishonored graves foster many a tale, and ghostly rumor is drawn to hard deaths. It is no wonder that all points in the tale of the Torture Tree get their psychic reports.

Mount Hope's stones and shrines are totems for the living as much as the dead. Its curious, hilly, wet ground has a natural ambience, which, combined with its trails and stonework, offers too many meditative places to count. It is so beautiful that people walk it like a park and so powerful that "witches"—probably Wiccans—have held ceremonies here.

The Boyd-Parker team's Mount Hope graves have their rumors. It is hard to say whether they pertain only to the displaced veterans. Before the Torture Tree candidates were brought here, the early Rochesterians were hearing reports from a swampy area near what is now Mount Hope and Elmwood Avenues: mystery lights, sounds, impressions, feelings and occasional indistinct apparitions. Mount Hope may also have a "Lady in Black," a vanishing hitchhiker who, unless she is a grieving widow, should have no connection to the wartime phantoms. A faint but unworldly howling has been reported as an occasional sound effect in the general area of the first Revolutionary burials. Perhaps you should ask the residents of the nearest University of Rochester dorm, located a few dozen feet from where these soldiers rest today, whether they've heard these noises.

The profile narrows when we turn to the Boyd-Parker Memorial near Cuylerville on the south side of Route 20-A. Much like the site of the longtime torture post in nearby Caledonia, the little riverside region received psychic reports for a few decades after the events. Shadowy figures were said to return for traumatic replays. Hunters steered clear

of the area after sunset. Locals reported echoes of the original events resounding through the groves and valleys.

Today, some locals claim not to know a thing about ghosts. It would figure. Many once haunted sites lose their mojo over time, at least as gauged by the folklore. But in 1999, a mighty tree spontaneously cracked and fell near the ambush site without explanation. The day was dead still.

Other tragedies that could have left a psychic mark took place here. Iroquois villages were uprooted as the whites moved into this part of the Genesee Valley. Both contemporary Native Americans and white psychics report the reverberations: whip cracks, rolling carriages, horses' hooves, the boots of troops, men's shouts and the weeping of women and children.

As we see, the bodies of the men of the Boyd-Parker expedition were treated at first like refuse and then like heroes. All the dead deserve respect, but it is hard to see that Boyd accomplished anything other than disobeying orders and getting his fool self and a bunch of others killed. In another light, on that fateful day, Boyd's rashness could have sprung a Seneca ambush that might have menaced Sullivan's whole army. And his troop gave their lives in a cause beyond them, however ill-figured their send-off may have been. Let them remain heroes.

Faded Coat of Blue

There is a strange monument on the north side of the road between Caledonia and Avon, a heavy boulder with a plaque that, last we heard, still gets a flag every Memorial Day.

Today's busy Route 5 is on top of the "Great Trail" that crosses the continent and was used for thousands of years to link the Hudson Valley and the Great Lakes. A war path as well as a trade and migration route, this east–west trail connected major Iroquois settlements between Buffalo and Albany. Many of them lie beneath today's cities, including Canandaigua, Geneva, Auburn, Syracuse and Utica.

Route 5 starts to merge with Route 20 just east of Avon. The two stay together for over sixty miles, all the way east to Auburn. If a road could be infused with psychic force like a wire with electricity, the first twenty or so miles of the highway would fit the bill. It is an area of high mystery to many contemporary Native Americans. The area is usually quiet, but occasional bouts of construction and development stir it up, causing accidents, apparitions, mystery lights and curses. A lot of the region's sightings of traditional Native American bogies' (witch lights) "altered animal" forms occur, when you plot them out, within walking distance of this old route, particularly at the point where Routes 5 and 20 overlap.

By the frontier days, this dirt path was the main thoroughfare between the Great Lakes and the East. Detachments of troops shuttled to and fro constantly during the War of 1812. Hostilities in these parts must have been winding down by a certain Saturday—payday—night in 1814.

A group of Americans had camped along this route not far from Avon. Some of the privates caroused so rousingly in a Caledonia pub that, come morning, two of them—John Alexander and William Comfit—would have had to be carried. They were left where they lay, but were expected to rejoin their troop as soon as they were able. By

Sunday evening, neither had reported for duty and the marshals went back to the pub to find them. One had not moved.

At about three o'clock on Sunday afternoon, a neighbor had heard a gunshot in the direction of the soldiers' former camp. Another went to the site and found a soldier shot through the forehead. The body was identified as that of Private Alexander. Like the contents of his wallet, his comrade was gone.

The marshals scoured the countryside. The unimaginative Comfit was soon spotted enjoying himself in a Canandaigua bar. He had a lot more than the sum of his own pay on him, and it was presumed that he had killed Alexander for the money. Comfit was quickly tried, convicted and executed. Alexander was buried near the Old State Road, not far from the site of his murder.

That spring, someone noticed a funny plant on Alexander's grave. By harvest time it was a waxy, lavender flower of a kind no one on the Genesee had ever seen. In a few years, the shoots spread to form the outline of the grave. Word traveled, and rumor spread that it was some kind of statement.

Buffalonian George Clinton had passed the grave many times and, like others, he wondered. In the summer of 1817, while on business in New Haven, Connecticut—the hometown of poor, murdered Alexander—he noticed the same plant growing all over. How "False Gromwell" had come to embellish a valley grave is still anyone's guess. It was not the only unusual occurrence connected to this case.

On the night of the murder in 1814, some of the old-timers had noticed a strange moon rising over the Genesee, one with a crimson tinge as though it bled. The natural night noises had kept an uneasy stillness as though all nature held its breath. Another thing rumored is that a third man may have been partying with the ill-fated pair.

William Morgan would come to no better end, though it would take a dozen years to catch him. Soon settling in Batavia, this Morgan would become a towering figure in valley legend who serves quite nicely as one of its most ubiquitous ghosts. The Caledonia pub involved in the tragic drink fest has been relocated uphill to the Genesee Country Museum at nearby Mumford. Allegedly, it is still haunted.

Two of three of these men have their monuments, both quirky. A big plaque-and-boulder marker was erected in memory of Alexander, who did nothing more heroic than get shot while drunk. Every fall in these parts, a number of valiant deer hunters manage the same feat. And Morgan's columnar effigy soars over a Batavia graveyard, grudgingly erected in the wake of a story we'll tell later.

As a final contrapuntal stroke, the plaque on Alexander's rock was inscribed with lines from a song from a different war, John Hugh MacNaughton's "The Faded Coat of Blue":

My brave lad he sleeps in his faded coat of blue,
In his lonely grave unknown lies the heart that beat so true.

There may be a disconnect in time, but the place is right on. MacNaughton (1829–91) was a valley poet of the Civil War period. May they all rest, and may this stretch of road stay at peace.

BLOOD KNEE DEEP FIRST!

At many of the bays around Rochester we've caught murky old rumors of lake apparitions that could be related to war clashes: phantom ships, flashes of light and even cannon fire and shouting. They feel "murky" to us because no one sees them any more. This doesn't mean they never did.

One such site is the tiny port and village of Charlotte on the western lip of the mouth of the Genesee River. This was an important stop on the intra-continental water routes long before Columbus arrived. Ontario Beach was a camp for Native American societies and anyone else who visited the valley by water. The first white family on this part of the Ontario, William and Mehitabel Hincher moved into a log cabin in 1792.

By 1804, Charlotte was a village and trading center whose fortunes were set when Canandaigua merchants widened the ancient Genesee foot trail into an ox-cart road. Likely named after the daughter of land agent Robert Troup, Charlotte was established in 1805 as a port of entry by Congress. Loud, smoky encounters in this part of the Ontario could have left psychic reverberations.

During the War of 1812, Rochester was just a village and was not in the British sights. But ports, ships and provisions were tempting targets and drew watery raids at Sodus, Oswego and the mouth of the Genesee. Early on the morning of October 12, 1812, a British squadron sent two boatloads of men to haul off a schooner, maybe two, from a dock at Charlotte. There were cannon shots fired, but little fighting.

Things got serious in 1813. On the morning of June 16, six British vessels drew up to Charlotte and dumped 150 soldiers on a foraging mission. It turned into a lively episode, with skirmishes, chases, escapes and ambushes. At length, the British held the town, lined everybody up and took hundreds of barrels of flour and pork and twelve hundred bushels of grain. They were long gone by the time 80 Penfield militiamen

showed up. Local legend has it that the ever-proper British officer gave the warehouse clerk a receipt for the goods taken.

Charlotte had been such a grocery store for the British that they were back the next fall. Throughout the day of September 11, a British fleet waited offshore, stalled in the still air. Charlotte residents gathered, and cannons fired from both sides for several hours. A rising wind not only let the British leave, but it also brought something to force them to do so: Commodore Chauncey's fleet. A naval clash started offshore, spun into the Ontario and lasted for several hours. British sailors were killed and British ships destroyed.

Approximately thirteen British ships bent on provisions came to Charlotte the following spring. An officer rowed close to shore, demanded a load of food and water and threatened to turn four hundred crazed Mohawks on the area unless he got what he wanted.

If Mohawks were truly crazed, or if he even had four hundred of the sane kind, the thirty-three-man local militia was going to make this Redcoat prove it. They marched in and out of the woods, fired guns, banged drums, yelled orders and faked the appearance of an army. They were backed by Port Charlotte's two cannons, a four-pounder and an eighteen-pounder hauled up from Canandaigua by seventeen oxen. The bluff worked. The British fired a couple cannons, but they never landed. The next day, Buffalo's General Peter Porter showed up with six hundred militia and the fleet departed.

But the live and hostile firing of the War of 1812 wasn't all the percussion that has visited Charlotte. In any place soldiers of this era were quartered, there would have been shooting and turmoil. (Genesee water was considered unhealthy without a bit of whiskey in it, and army salt pork made everyone thirsty.) And we forget how much hysteria there was during the American Civil War. Even this far north, people worried constantly about saboteurs and invasion from Canada. In November 1864, one such flap took the lower Genesee by storm, resulting in cannons firing at a shocked and innocent schooner.

World War II came calling when the U.S. military staged a fake invasion of Ontario Beach on Independence Day 1945. Onlookers filled with patriotic admiration packed the pier to cheer the forces that had just won the biggest war in history. They got a dose of shock and awe. D-Day– and Okinawa-style weapons assaulted the air and water, hoisted spumes of sand and, according to the *Democrat and Chronicle* reporter, assailed the spectators with "the most terrific sounds that have reverberated in the human ear." Possibly grasping for the first time what

had just befallen Europe and Asia, the would-be cheerleaders froze. This alone could have left an aftershock.

The British sailed many a time near the mouth of the Genesee River during the course of the War of 1812. Admiral James Yeo's thirteen ships have been seen by Charlotte, fading as they retreat over the Ontario. Coastal apparitions include those of the plucky Rochesterians marching in and out of cover. Witnesses have even reported the ghost of an old soldier and his defiant chant: "Blood knee deep first!"

GHOST SHIPS

The Great Lakes are deep, dark and dangerous. It is estimated that they may have swallowed ten thousand ships and forty thousand people in the past two centuries. The pattern suggests that these inland oceans may have their own disaster zone like the famed "Bermuda Triangle." It is no surprise that supernatural tradition gathers.

Ghost ships—often nicknamed "Flying Dutchmen"—are seen all over the Great Lakes. The oldest is the first European-style craft that navigated the lakes, La Salle's 1679 galleon, the *Gryphon*, on double duty, haunting more than one lake. The most recent may be the *Edmund Fitzgerald*, whose truly spectacular disappearance is remembered in Gordon Lightfoot's 1975 ballad. Psychic folklore even surrounds the hulk at the bottom of Lake Superior.

There were doubtless skirmishes and run-ins all over the two eastern lakes that haven't made it into the books as battles. Many ghost ships on Lakes Erie and Ontario seem related to the 1812 period. Those include sightings on Lake Erie at the mouths of the Silver and Cattaraugus Creeks, and on Lake Ontario at Sodus Bay (site of a battle) and at Braddock's Bay near Charlotte. Those reported near the mouth of the Genesee River would seem to be war related as well, since they are often accompanied by flashing and percussion, and they surface at known or suspected encounter sites. Catch them while you can. The usual lifespan of a ghost—if such can be said to have a "life"—seems to be about two hundred years.

The Valley Heavies

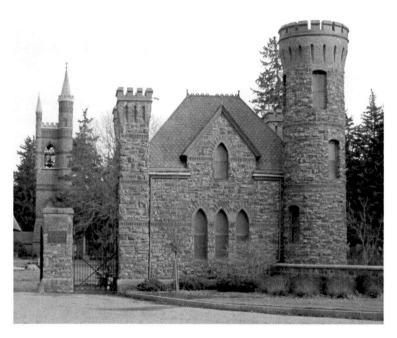

Holy Sepulchre Cemetery.

GHOSTLY FORMS

Not all psychic experiences include sightings of apparitions. In those that do, only some apparitions look like people at all, much less recognizable ones. The images recur in patterns like representatives of a type, as if they could be messages from the mass mind or the energies of a place. This is a chapter about ghostly forms on which local folklore has had a field day.

The Little Girl Ghost is probably the most common ghost anywhere. Local folklore seldom gives her an identity. ("A little girl killed in a fire" is the closest we usually get, whether or not there ever was a fire.) Every community must have several stories about her. We hear so many of them that we just write "LGG" in our pads during interviews.

Adult forms tend to be more developed. In the case of the Woman in White, surely the number two ghost, local folklore more often has an explanation and even a name. By *women in white* (WWs) of course, we mean "women ghosts." Though each version almost always inclines to the pale side, "she comes in colors," or should we say, pastels. They run rampant in Western New York, these ladies in:

> Lavender (Lancaster)
> Red (North Tonawanda)
> Black (Batavia, Rochester and Wales)
> Gray (Penn Yan and Rochester)
> Blue (Bluff Point and the mines at Cuylerville)
> White (Irondequoit, Lockport, Orchard Park, Lewiston, Victor, etc.)

Other WWs (some famous individually) haunt Canandaigua, East Aurora, Ellicottville, Geneseo, Geneva, Jamestown, Lancaster, Wellsville and who knows where else. Buffalo has enough that they've formed a *City of Light* book club. A squad of them regularly power walks through Forest Lawn Cemetery.

Doubtless these women in white ride shotgun on the other phantoms—the little boy ghosts, the old farmers, the soldiers, the horses and riders, the phantom dogs and cats and the ghostly cars, ships, trains and battles that make us suspect the ghostly biomass is not all organic.

But then we have the gnarlies—forms of things that have never had a social security number and often come through with an edge. Here's to the "Heavies," those unidentifiable shadows, "Black Dogs" and demonic spooks who could be almost anything.

HELL'S HERDER

Lake Ontario, into which the Genesee River feeds, is the only Great Lake with a natural passage to the Atlantic. It was famous to the Iroquois as the home of their Great Horned Snake, which was sort of an anti-being to their Thunder God. The matter crosses from the mythological to the paranormal in Western New York, full of historic sightings of lake and river critters like Scotland's famous Nessie. Lake Ontario may be more sinister, though, for an apparition that falls among the ghostly: the Black Dog of the Lakes.

These black dog apparitions seem different from the usual ghost. Figments of old folklore, they're often considered servants of heaven or hell, rounding up sinners' souls and herding them back to the netherworld. They are archetypes, eternal images that cry some primal word from the unconscious mind. They are rare in the United States, but people still report them.

These black dogs so often appear at graveyards and along "corpse paths"—routes between graveyard and church—that they're interpreted as guardians. They warn the living and protect the dead. It is also difficult to know whether a black dog is more than a plain dog ghost. (Yes, there are animal ghosts. Almost all animal ghosts that we hear about are traditional, domestic dogs, cats and horses. No spritely springboks, for instance, or ghostly gerbils.)

But where the Genesee Valley is concerned, the most prominent black dog is a wet one. One of the Great Lakes' most potent bogies is "the Black Dog," named in at least four shipwrecks on the eastern Lakes Erie and Ontario. Survivors reported the sable spaniel walking their decks in the blackness as though it owned them. The nether canine was reputed to be the ghost of a natural dog that fell off its ship in the Welland Canal. Its first victims were the sailors who laughed as it drowned.

A couple Ontario tales are making their rounds. As the canal schooner *Mary Jane* was being towed out of Port Colborne, Ontario, some workers

noticed a big black Newfoundland with eyes "like coals of fire" on the deck. It walked across a load of wooden posts, jumped to the dock and vanished. The *Mary Jane* was lost with all hands.

The most famous comes from November 1875. One still night, a three-masted schooner, the *T.G. Jenkins*, was on its way from Chicago to Kingston, Ontario. A helmsman woke his mates, claiming to have seen "the Dog" on the deck. It climbed off the lake surface, crossed the deck, hopped the rail and set off walking again. The helmsman was kicked off for drinking. Somewhere north of Rochester, the *T.G. Jenkins* was lost. Neither bodies nor wreckage were found.

The night the schooner was lost, a farmer at Sheldon's Point (east of Rochester) saw a strange black dog come ashore. Its hair was matted and its hindquarters trailed as if paralyzed. The farmer claimed it looked a bit self-satisfied, and then it vanished.

The black dog was so fearsome that even using its name in a curse was trouble. On stormy nights, its hellish howling is sometimes heard, and sailors still pray that it sets no paw on their decks.

LADY OF THE LAKE

To passersby, "the White Lady's Castle" may become a spectral palace under the occasional moonlight. What we see in daylight—a cobblestone wall—is all that's left of a 1911 lakeside hotel closed by the Depression and demolished in the 1970s. This is far from the antiquity presumed of Monroe County's most famous—and dangerous—ghost. The Genesee Valley's own "Lady of the Lake" is so strong in tradition that it is hard to be certain where fact ends and fiction begins.

A territorial spook she is, the White Lady of Irondequoit and Durand-Eastman Park. Bounded on the west by the Genesee, the north by the Ontario and the east by Irondequoit Bay, this was marshy, dangerous, mysterious ground when the first whites saw it. Even the draining of the swamps hasn't killed its psychic vigor.

Its legendary haunter rises from the water, sheeny as the mist that dabs the moonlight. On misty eves, they say, in the summer months, her white-shrouded form walks, two wolf-like dogs at her side. Across Tamarack Swamp and Durand Lake they search, sometimes wailing and snarling.

The rumor cycle profiles her as the mother wronged. The mortal woman who became the White Lady had lived where the park now stands in the nineteenth century. Her daughter took a walk and didn't return. The neighbor who violated and killed the girl pitched her body into the lake. The mother stalked obsessively, she and her ominous pets. When she became certain that she would never find her girl, the mother ended her life, possibly giving herself to the waters and unleashing that restless soul with a curse.

She may take form between the Huntingdon Hills, near where she lived, and the former zoo. Some who have seen her say she rises from the water as if she comes from its substance; as if the lake to which she gave herself on occasion gives her back. Soon, the ghostly hounds are by her side, and off they go again. To some, she is fey and poignant, to others

haggard and threatening. She is an avenger. The girls have nothing to fear, they say, but the men better have good hearts.

Was there a real event behind the tale? Irondequoit historian Walter Sasserman made a study of this communal ghost and found nothing to back the saga. He was convinced that it was developed by the young men of the region, the better for drawing their young lovelies closer while parking at this proverbial Lover's Lane.

You could fool others. Enough people have seen the White Lady to make this ghost a celebrity. The village celebrates her at summer parades and Halloween tours. She has even inspired a film, Frank LaLoggia's *The Lady in White* (1988). And Irondequoit residents still report seeing the lady near her castle. Some young partiers interviewed by the *Rochester Democrat and Chronicle* in 2001 were so shocked to see her manifesting—a ghostly *thing* in white—that they jumped into Durand Lake to escape her. Director J. Burkhart of Rochester Paranormal has a blurry photo that he believes could be her.

The stark form of the White Lady is an archetype that could have sprung like Athena from the brow of her imaginers. Like the Greek goddess they call "the Queen of the Air," she stands for something strong enough to need expressing. We would have created her by now if she did not already exist. "The Psychoid Archetype," Jung calls it—this image thought so hard by so many that it starts now and then to get up and walk. Do we need this vigilante in the valley, keeping the afterlife faunae in check?

THE DEMON ROAD

Manitou Road is twelve miles or so long, a north–south stretch connecting Buffalo Road—Route 33—with the Ontario shore around Braddock's Bay. It crosses both the Erie Canal and the ancient trail that became the Ridge Road. A local tradition has developed around something otherworldly that terrorizes the area. Historian Shirley Cox Husted recalled this tradition and even a personal experience.

One dark night she was torn out of sleep by the claws at the window of her bedroom in her brother's Manitou Road farmhouse. Something toothed, taloned and terrible was about to hurl itself through the glass. It disappeared as it met the pane, but the shock it gave her lasted. She screamed and the household came running. She had imagined it, everyone said, as they said years later when the very fiend or one like it woke a child in the same house. Do they say that to the motorists who report it buzzing them? And when her brother's wife passed over, he closed the shades at night for the rest of his life, as if he never wanted to look out into darkness on Manitou Road.

The name is suggestive and deeply charged. There is no certainty how it got there.

Manitou is the Ojibway-Algonkian power word for the force of life, earth and magic. While popular films and fiction link the term with occult evil—much the way they did for so long with the word *druid*—it means something like the Asian *ch'i*, roughly, "world spirit" or "life force." *Manitou* lasts today in many place names throughout the United States and Canada, but it is funny to find it in the Genesee Valley. There were Algonkian settlements here, but they were long gone by the time the whites arrived and started naming things.

For Algonkian communities, *manitou* was a designator of human and natural power sites at which rock carvings and other sacred markers are often found today. Succeeding cultures usually adopt the shrines and

sacred sites of those they displace. The name is the last outward sign. When one of these power words survives, we had better listen to it.

The matter of the Manitou Demon could be nothing but a simple ghost report with an air of the folkloric. It might also be the way ancient force shows itself sometimes—in chaos that the contemporary Western mind interprets as hostility.

THE DUST DEVIL
OF BOUGHTON HILL

Boughton Hill in Victor, southeast of Rochester, is just a crossroads today. It was a farming community in the 1800s and a battlefield in Denonville's 1687 expedition to the nearby Seneca settlement Gannogaro (today's Ganondagan). We talked about the battle in an earlier chapter, but the trauma here may not have been only that suffered by the Senecas. A Dutch traveler, Wentworth Greenhalgh, visited the site in 1677 and saw a handful of captives killed. Even in peacetime, Gannogaro could be a rough place.

In the 1960s, a centuries-old grave was found somewhere nearby. The grave held the facedown body of a woman, apparently executed as a witch. Facedown burial was common in many societies, as it was thought to ensure that a vengeful spirit would look the wrong way for its tormentors.

Late Fishers historian J. Sheldon Fisher shared a tale about Boughton Hill. As a family raked leaves, one of the children ran outside, leaving the door open. The mother noticed a swirl of leaves and bits across the lawn that had formed an odd, human-sized whirlwind. To the Scots or Irish, this would have been a sign of "the Little People" passing. Who knows what the Senecas would have said. But this dust devil approached the house and made straight for the open door. Something told the mother to beat it to the spot, but she was too late! The little tornado doffed its particles on the doorstep as if it had shed a disguise and entered. The house was still, but "something felt different."

In the coming weeks, every member of the family felt an unmistakable discomfort. Psychic phenomena broke out all over the house and a pattern seemed to be escalating.

A family friend was a Seneca elder who lived nearby. As if he sensed something, he paid the family a visit. At one point, the dog he brought with him stared, froze and bristled, alarmed by an invisible presence people could track through his gaze. "Let me have the house for awhile," the elder said. He left, came back with herbs and implements and commenced a ritual to clear the house. Soon all was at peace.

Jesus on the Thruway...
and Friends

We get the picture: sleet cuts the black air. Headlights blur and wipers streak windshields. A driver sees a form by the side of a road and pulls over to find the waifish child/slender teen/addled crone either by a cemetery and specifying an address or somewhere else and asking for a ride to a burial ground. She gets in. The driver lamely attempts to chat, and at one point turns—usually in sight of the destination, often after crossing a bridge—and sees that the passenger has disappeared. The vanishing hitchhiker strikes again!

Vanishing hitchhikers aren't all female. Girls just dominate the folklore, and there could be good reasons—they may be the only roadside ghosts anyone would stop for. Would you pick up the Black Dog, the Manitou Demon or the White Lady of Irondequoit with her snarling hounds?

Though it has to be considered some kind of apparition, the vanishing hitchhiker is an atypical ghost. It often speaks, for one thing. It gives signs of being material, sliding across a car seat, closing a door. It may even give off a scent.

Another curious feature of the vanishing hitchhiker, at least the local variety, is that there is often some confusion about which sort of spook it is: Woman in White, Little Girl Ghost or Old Lady Spook. Does the apparition come through incompletely, accounting for the variance in aspect? There are a number like this in Western New York, including at Canandaigua, Lockport, Kenmore, Victor and Rochester.

One of Rochester's most famous vanishing hitchhikers is the Lady in Gray. She can be seen now and then on Lake or Dewey Avenues near Holy Sepulchre Cemetery. When she says anything, it is always a request to go to the "the Four Corners," the city's first business district at State Avenue and Exchange Street. State/Lake Avenue is an old north–south trail along the river—the path of war for the Senecas.

But there is more to this story. She could quite well be some kind of avenger, gifted with a threatening mien. In some reports she—or

whichever vanishing hitchhiker gets picked up here——is a Lady in Black or even an old couple.

Western New York had these figures long before the studies of Jan Harold Brunvand, who takes these hitchhikers purely as story types and not as psychic/paranormal reports. The witnesses, invariably third hand, are always the famous "friends of a friend."

There are also male vanishing hitchhikers, typically old drunks or young hippies, and some overlap into the paranormal. There are eyewitnesses, some of whom call the police. One of the most interesting vanishing hitchhikers rumored to haunt the Genesee Valley was the mid-1970s apparition of a crazed male, prone to portents and prophecies, along I-90. He may have been active between Batavia and the easternmost of the Rochester exits. There was even talk of him being a white-robed Christ, predicting World War III before taking a powder.

This was about the time that John Gardner's *The Sunlight Dialogues* (1972) was at its apex. Batavia's Gardner (1933–82) was a world-class writer and scholar who not only found inspiration in the village of his birth, but also cut quite a figure—a near-albino Rapunzel—about it. Gardner lies in Batavia's Grandview Cemetery beside the brother he killed in a childhood accident. One wonders if Gardner's novel about the elusive, prophetic Sunlight Man of Batavia could inspire the regional mass mind to begin imagining him, or if the book could have been inspired by something from life. And there are other takes on this as well: a know-it-all longhair thumbing it up I-90 could have been this book's editor as a college kid. Now, where did I put those robes?

ONE-SHOT WONDERS

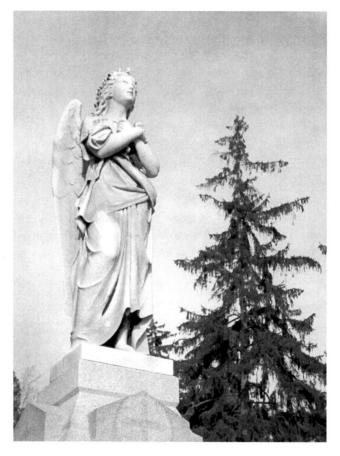

A mournful angel watches over the cemetery.

PSYCHIC HAPPENINGS

M ost ghostly situations that are famous enough to write about feature famous ghosts or haunted sites. Either aspect can last for centuries and build quite a body of legend. Other events that may be no less "supernatural" may be one-offs, acting up for a short spell and playing out to mere handfuls of people. We needed a section for the single shots.

Ghosts who come back with a message and intelligence are usually one-shots and often qualify as "crisis apparitions." Physical psi, too—the typical poltergeist outbreak—may be likewise dramatic, but with a very short window.

Rochester has had a handful of these episodes, some of them involving only a single stroke and some of them unclassifiable. You know the drill: wrathful ghosts, religious miracles, a dance that becomes a mass séance, poltergeist outbreaks as grand as works of nature. They don't fit into any other section in this book. Hold on to your hats.

A Head Start on Hell

Avenging ghosts and otherworldly persecutions are usually just features of folklore. Usually.

It was one of the sadder events of 1900. On November 20, an attractive brunette looking for a job knocked on a door at 127 Davis Street. The next morning, Theresa "Tessie" Keating, age twenty-eight, was found behind a billboard near the railroad tracks in the center of Rochester. The matter set off a citywide alarm and sparked a vengeful mood.

Though the modus operandi of Ms. Keating's killer and Jack the Ripper were different—she had been beaten to death and probably violated beforehand—this was a scandal of Ripperesque proportions; a killer to which the Flower City had connections. (Rochester resident Francis Tumblety (1830?–1903) was a prime candidate to have been London's serial murderer.) At least sixty suspects were interviewed, most with little possible connection.

As an example, Hobart Fuller, a seventeen-year-old Canadian working as a janitor, found himself fingered because a Canadian coin turned up near the body site. Any one of twenty-five thousand people who toured the site could have dropped it. But it seemed like a clue to someone, and vigilante justice was not unknown in Western New York. ("Murdered Mason" William Morgan and Mormon founder Joseph Smith come to mind.) Fuller took the hint and hightailed it, landing eventually in South Africa to join the British fighting the Boer War. He was almost certainly innocent.

Three years later, a Belgian immigrant farmhand named August Russell visited his doctor with insomnia. His house was so haunted that he could get no sleep. He saw things in the night. Voices called to him and footsteps sounded as if something was coming for him. He saw ghosts, too, apparitions of a young, dark-haired woman. The savvy doctor pushed a little and it all came out. Russell knew the young woman he saw in his sleep. She was indeed Tessie Keating and he had killed her. He had

already admitted the crime to his wife, but by then it was clear that he would get no rest until he took his punishment.

Russell ended his days in the Matteawan prison for the criminally insane. No doubt his ghosts made him look crazy to the already skeptical society around him, and it seemed like mercy to let him live. But could it have been orchestrated by a vengeful spirit, who had him to herself many more years? It was a head start on hell.

We have enough of these avenging females in the psychic fauna of Rochester. Think of them: the White Lady of Irondequoit, the White Lady of Victor, the Grey Lady of Holy Sepulchre, Eliza of the Trackways. We also have the legacy of suffragettes in the region including Susan B. Anthony and Clara Barton. It is a bad thing to hurt any person, but the lower Genesee Valley may be a worse place to hurt a woman. Maybe the veil between the worlds is thinner here, and the justice of the otherworld doesn't need to wait.

THE PHANTOM
AND THE FAUSTUS

Tenor Vladimir "Val" Rosing (1890–1963) made his debut in Russia in 1910. Before long, his cultured St. Petersburg family disappeared and he fled the murderous tumult preceding the revolution. By 1912, he was acting and directing London operas. By 1939, he was singing, acting, dancing, producing and directing in Hollywood. Though George Bernard Shaw praised Rosing as "more than a tenor…he is the whole band," in the grand scheme of things, his gifts may have been behind the stage. His moment in this book comes in 1923, on the deck of a liner crossing the ocean.

The young expatriate who had seen and done so much had a big spirit. He must also have been a talker. Maybe something in the sky brought him out, the slant of waning sunlight on the Atlantic clouds. He may not have known the composed stranger to whom he sounded off. Among Rosing's dreams was bringing the highest forms of musical art, including opera, to the man or woman in the American street.

A few months later, Rosing got a cable from the man with whom he had shared that sunset—Rochester's photography tycoon George Eastman. Soon, he found himself a leading figure of "the Rochester Renaissance" and directing the Eastman School of Music. A dramatic psychic experience comes from this Rochester stay, preserved for us by Paul Horgan in his 1936 *Harper's* article.

Ontario winters can be bleak. In 1924, Rosing's company was looking for indoor entertainment and held an after-hours séance. The occasional "circle" isn't unusual in the home base of Spiritualism, and the cast may have had magic on the mind. They were at work on Gounod's opera *Faust*, about a medieval German doctor who sold his soul to the devil. These "witchy" plays often develop supernatural auras. (Think of *Macbeth*.)

Eight living souls held hands over a heavy mahogany table in the Rochester apartment of Rosing's fiancé Peggy Williamson. On this device, with its griffins' claw legs, an invisible guest conveyed his message, evidently through rapping sounds and the code devised by the early Spiritualists.

Perhaps inspired by the ominous play, the Rochester spook called itself Faustus and said it had come to Rochester to set a few things straight about the life of the real man. It then treated the group to a mediumistic display like those of the century before. The heavy table moved itself, sliding, lifting, tapping and banging to make its answers. This terrified some of the attendees.

The spook's utterances, though, were comic relief. It rapped out resolutions like the titles of New Age CDs, ponderous only because of their unvisualizables (life, soul, secret, words, world). This spirit of Faust had a new wrinkle. It promised a display at the Eastman Theater at the company's next performance, and it seemed to deliver.

During the show, a cross of light manifested on the stage floor, danced about for a few seconds and vanished. No one had been in the light room at the time, and neither the light crew nor the projector operator could explain the effect.

The detached observer eight decades later can't say much about this event. The success of the remarkable 1970s "Philip Experiment" in Toronto seems to validate the possibility of psychic phenomena being produced on cue for willing individuals.

Of Eastman, we shall hear more. As for Rosing, people remember him, but some have noted a want of elaboration about many details of his life. The sense of a "big picture" is missing, which lends a spark of intrigue, if not mystery, to Val Rosing. He was never a big wheel in Tinseltown, but he was busy, active and successful, and he seems to have been well liked to the end of his days. He had several marriages, left many descendants and seems to have led a great American life. He must have done all this, though, with a heavy heart all his life. The loss of a family could do that.

THE GOBLIN SLINGER

One aspect of the broad field of the paranormal is often called *phenomenalism*—the study of anomalous phenomena. It is also called *Forteana* after its founder, author Charles Fort (1874–1932). The Bronx resident spent his adult life collecting odd news reports from around the world that he compiled into his four books. His subjects favor several categories.

Through his focus on mystery lights and human disappearances, Fort might be memorable to us as the first forecaster of what has become the UFO craze. He was also fond of unexplained sounds and explosions and out-of-place artifacts. A true specialty was the crazy falling of objects from the sky. Unnatural precipitants range from the mineral (stones) to the edible (nuts). Even living rains—fish or frogs—have been appearing in the records for centuries.

Carrying on Fort's work, contemporary researchers Janet and Colin Bord mention several spooky showers in Western New York. Flocks of tiny fish fell at Buffalo in 1900, Niagara Falls in 1933 and Buffalo again in 1939. Cardboard-like substances showered Elmira in 1956. Gentle falls of pebbles assailed fishermen on Skaneateles Lake in October 1973. A certain Greece event in 1973 would have been right up Fort's alley.

On December 9, 1979, the *Rochester Democrat and Chronicle* ran an odd, six-year-old story. For several nights in November 1973, the home of the Frank Marrella family on Carmas Drive was showered with rocks of variable sizes. None were bigger than baseballs, but the event was scary.

Of course, the authorities checked into every imaginable possibility. Human vandals were the first in anyone's mind, even with the slim chance that they could all have remained hidden. These rocks came from many directions. There would have had to have been secret caches of them all over the neighborhood, as well as a conspiracy of covert and well-timed hurlers. During one onslaught, the police came in full force,

sealed off the tossing range and scoured it. Not only was the search for phantom pitchers fruitless, but also the assault kept up the entire time, even targeting police cars. Fortunately for all, the wonder was over in five nights.

Except in the cases of minnows falling beside lakes just after waterspouts, we know of no explanation for strange showers of objects like those observed by Charles Fort. We are clutching at straws with the rocky rain in Greece. Because of the scale of the event, we're almost thinking in seismic terms, as if there could be some earthly energy source that combined with other factors to raise and hurl small rocks. This force, of course, is completely unaccepted at this moment by science.

The Greece event may get stranger from another perspective. Unlike typical ghost, beastie and UFO sightings, plenty of evidence was left behind in Greece. Where did so many flingable rocks even come from? It would be fun to locate some of the originals hurled in 1973 and see if they could be tracked to a source. It would also be interesting to know the Native American roots of the site. But for the scale, this event sounds like the "elf shot" legendary in Celtic countries.

The oddest effects of this matter in Greece, however, may be the damage it did *not* cause. Think of a random firing of stones; if you lobbed a couple hundred into the average neighborhood, how many people do you think you might hit in a week? How many cars? This shower broke a few windows and gashed the sides of the Marrella house, but as far as we know, no one was injured.

Strange relocations of material objects are usually called *apports.* They are familiar in the cases of poltergeists and religious miracles. The Greece case reminds us of classic poltergeist outbreaks in which people should have been hurt—could hardly have avoided being hurt—and were not. In fact, this is one of the distinguishing features of documented poltergeist cases (as opposed to entertainment ones): they do vastly less personal damage than could be expected, almost as if the agent were using its preternatural gifts to be on the lookout against harm.

THE TEDDI DANCE

February. The grimmest, darkest, coldest month on Lake Ontario. It is also the month of Saints Valentine and Brigid, spirits of light and heart, without which March's trumpet and April's lovely prime might never be. Surely there's something in February that anticipates.

Elizabeth "Teddi" Mervis was not your average little girl. In 1979, at the age of twelve, she was diagnosed with a brain tumor. The next few years were anguishing. Teddi faced the whirl of doctor visits and all other challenges with a grace and composure rare even in adults. There was another problem besides the prospect of early death. Her father could see it. She was missing her childhood. That was about to change.

Within a year of Teddi's diagnosis, Gary Mervis founded Camp Good Days (now Camp Good Days and Special Times Inc.). Here, Teddi and other children with terminal illnesses could swim, hike, explore, sing, play and laugh. Though sadness disappeared, the ailments seldom did. Elizabeth Mervis died in February 1982. Every summer since, about a thousand children attend the camp inspired by Teddi to rediscover what makes them children.

Dr. Lou Buttino, then a professor at St. John Fisher College, was a dear friend of the Mervis family. Like so many, he was devastated by Teddi's loss and felt helpless against the ailments that plague the most innocent. In the month of her passing, he confided this to a class at St. John Fisher. It was this class who conceived the idea of a dance marathon to raise money for ill children and keep the memory of them alive. The Teddi Dance for Love was born. A few dozen dancers raised $7,500, and each February at St. John Fisher the dance has continued. Approximately five hundred dancers per year often raise $25,000. Over fifteen hundred children have been to Walt Disney World and other sites in Florida as a result.

Anyone who has done much dancing knows what a workout it can be. The Teddi Dance is a physical and emotional challenge. The

all-night ordeal evokes a war between the body's fatigue and the mind's determination. In many world cultures, the dance is used to evoke the trance state. At the peak of this battle between nature and spirit, many at the Teddi Dance report the strangest thing: a girl's voice, always soft, encouraging, hopeful, insistent and always saying the dancer's first name. It is Teddi. The dancer turns to look, and she is gone like an inspiring gust of wind, leaving the hearer breathless but energized. The will returns to dance, for Teddi and for love.

At the end of each event, the children for whom they are dancing join the exhausted dancers in a passionate finale, and hundreds of balloons are dropped from the ceiling. Some years a single pink one makes an appearance, even though none of this color are ever ordered. Is this a reminder of Teddi's enduring spirit? Ah...February.

THE BLUE MARY

Except for their imagery and overtones, religious miracles at least look like the usual run of phenomena labeled *psychic*—ones presumed to originate with the human mind, spirit or psyche. These may be apparitions, healings or altered or relocated objects.

Today, the study of religious miracles has what verges on a cottage industry: *Marianology*, or the study of the Blessed Virgin Mary and associated apparitions. Nothing in the realm of the religious paranormal is more controversial and unique. Her encounters can be dire and brief, her messages politically tinged and her whole experience projected from the collective psyche.

The Catholic Church has its reservations about Marian reports, and its sanction is rare, such as with Guadalupe, Mexico (1531), or Fatima, Portugal (1917). A vision series that started in 1981 in Bosnia-Herzegovina has never gotten official backing, but this hasn't stopped *Medjugorje* from developing a following. With such a spectrum of themes, sites and sightings, it is little wonder that Rochester could be a stop on the queen of heaven's world tour. The location was St. Mary's Hospital by the former Bull's Head crossroads at West Main and Genesee Streets—yet another A.J. Warner building site to attract psychic rumor.

Three nuns from the French order Sisters of Charity started the city's first hospital with just five doctors in 1857. Opening in 1863 in a fine Lombard/Romanesque building, St. Mary's became a significant Civil War hospital, treating five thousand bluecoats in its day and lasting until 1999, when it closed to form the Unity–St. Mary's Medical Campus. The sisters kept their affiliation with St. Mary's through the years, living as frugally as possible and even sleeping on straw mattresses in the early days. In 1974, they got help they never expected.

A large statue of the Blessed Virgin Mary was prominently displayed at the hospital. It disappeared, and the day after, strange things started

happening. Terminally ill patients remarked upon the beautiful nurse who had comforted them in their worst hours. Neither they nor the staff had ever seen her before, stunning, joyful and resplendent in the traditional colors of the Blessed Virgin. All died soon after a visit from the "Lady in Blue."

The hospital staff couldn't pin her down. They just missed her visits with patients. Some caught glimpses of her at the end of hallways and even chased her, but they couldn't get close to her or tell where she had gone. Those who saw her, though, were positive. Some even signed statements.

As is common, a cycle of Marian visions can end as abruptly as it started. Two weeks after the first sighting, the "Lady in Blue" came no more.

Hospitals are places of life transition—birth, death and healing. Some sensitives can't set foot inside them because of the baggage they collect. And they attract their ghost stories. If the apparition at St. Mary's wasn't a typical "Woman in White" of the blue variety, it could very well have been a new nurse, as some said, who worked only a couple weeks. Oddly though, the day after the Lady in Blue's last appearance, the missing statue reappeared. Surely a coincidence.

Sweet Valley Sites

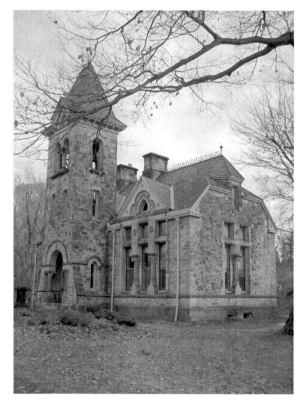

Mount Hope.

HAUNTED BUILDINGS

Haunted buildings and famous ghosts. Entertainment sources make us think in these terms when the subject is the supernatural. Part of the reason this book has developed as it has is to show nonexperts that there is so much more.

If there's one thing we think we know about ghosts, it is that they are site specific. The garden-variety apparition is almost never reliably reported outside a certain, very localized space. This is a chapter about these places.

Some of you might think it would be hard to come up with ten or so haunted hotspots in a fairly young American city. Think again. Not only does supernatural gossip thrive wherever people live, but Rochester's haunts are well publicized.

Rochester's paper, the *Democrat and Chronicle*, has been a good friend of ghosts, and during most Halloween seasons it runs an article profiling a handful of sites. By now there is quite a file. In 1982, historian Shirley Cox Husted captured generations of Monroe County tradition in her short book *Valley of the Ghosts*. Cindy Boyer's 2004 *Ghost Walk* imaginatively revisits Rochester haunts and events. The young Internet is virtually responsible for the new craze of ghost hunting and has helped form general opinion about haunted sites all over the United States. In a book the length of ours, the problem really is what to leave out.

Some people will give "reasons" for ghosts to come back. To us, it seems preposterous to psychoanalyze things that many people don't even believe in. We can only judge ghosts by patterns in reports and traditions. Two interesting patterns gravitate to sites.

First, many buildings that grow famous for being haunted may have no apparition reports at all. Their reputations come from physical phenomena—sounds, electrical tricks, moving objects—that the public blames on "ghosts." It is as if the building or site is a big generator of

reality glitches. It is so common a picture that we use a shorthand for it: SPOTUK (Spooky Phenomena of the Usual Kind).

Second, many people who work or live in an allegedly haunted site state flatly that they've never seen anything spooky. Does that prove the place isn't haunted? Maybe. But others have had experiences there, and they claim it *is* haunted. Does that prove that it is? One's take in each case may depend on one's initial attitudes, such as is the case in, regrettably, too many other subjects, including U.S. politics. We're going to write about some valley sites and what people have said about them.

GHOST OF A BUILDING

One of Rochester's Victorian hotspots was on Exchange Place (later Corinthian Street) behind the Reynolds Arcade on Main Street. The Athenaeum Building was an assembly hall built for financier William Reynolds in 1849. (Anything called *Athenaeum* is aimed at promoting culture and named after the Greek war/wisdom goddess Athena.) The rack of Corinthian-style columns on the stage was what everyone remembered about this building that was soon to be called Corinthian Hall.

The 1897 city directory gives the address as Exchange Place, which then ran from 33 Front Street West to 20 State Street. Big for its day, this architectural gem seated twelve hundred people and held a law library, reading rooms and office space. An entertainment hall and convention center, the Corinthian's theater was specialized for speaking and listening. Legendary *New York Tribune* newspaperman Horace Greeley wrote of "its lofty ceiling, admirable lighting, and air ventilation." A wide range of period luminaries took its stage.

As a lecture hall, the Corinthian was a forum for progressive political ideas as well as alternative subjects like mesmerism and phrenology. Literary events included Shakespearean readings and visits from authors, among them Charles Dickens. Performers like showman P.T. Barnum and singer/dancer Jenny Lind ("the Swedish Nightingale") graced the stage, with political stars like abolitionist Frederick Douglass, suffragette Susan B. Anthony, statesman William Lloyd Garrison and Lincoln cabinet member William H. Seward. Sheer spectacle took place here, too, like gymnastics and "the manly pugilist arts" (boxing). Some visitants may not have been mortal.

By the fall of 1849, two country girls from nearby Hydesville were getting famous. In the presence of Maggie and Katie Fox, "the spirits"—or something—made knocking sounds and could even be coerced into a sort of code. In one session at a Rochester home, the spirits told the sisters, "Hire Corinthian Hall."

Approximately four hundred of the city's curious residents showed up on Wednesday, November 14. Author and minister Eliab Capron lectured on "the full history of the rise and progress of these strange manifestations." The sisters paraded out to applause and catcalls and sat or stood quietly. A metallic knocking announced that the spirits were ready. Then the blunt raps commenced, but from where they came—walls, ceilings or floors—no one agreed. For all three demonstrations, the girls were studied by selected audience members, sometimes even held or bound. No trickery was proved.

These demonstrations tested everybody. Some religious folks picketed the shows of apparent *necromancy*, or speaking to the dead. Others came to expose the trick and stormed the stage to check for themselves. Some shows were near riots. Known then and remembered today as "the Rochester Knockings," the three Corinthian Hall displays launched an international craze and founded a religion.

Corinthian Hall came to be called "the Academy of Music" and was lost to fire in 1898. Rebuilt in 1904 as the Corinthian Theater, it closed in 1928 and was razed a year later. Some of the old streets don't exist now, and its foundations are hard to pinpoint. Some say they lie beneath a parking garage, and others claim that they're under the Crowne Plaza Hotel. A Civil War–era city map inclines us to the latter. Possibly supporting our belief further, the hotel's employees report an array of psychic phenomena, including ghostly cheers and applause in various parts of the building as if the site echoes its past. A ghost, a stunning woman in Victorian clothing, has been reported walking the halls. Could this be "the Swedish Nightingale" looking for the long demolished stage? If so, it's her second Western New York stop, the other being Lewiston's Frontier House.

Corinthian Hall may be as interesting for its architectural pedigree. Its designer was Henry Searle (1809–92), one of the region's most influential architects, known for classically inspired and also haunted courthouses in Lyons and Canandaigua. His son, Henry Robinson Searle (1836–1882), was involved in the Egyptianate styling sweeping the United States in his day. His enigmatic design for the Washington Monument was rejected in favor of our primal obelisk, but it won young Searle a place in the American Philosophical Society, which is sometimes considered to be an esoteric outfit like the Masonic/Rosicrucian "Invisible College" of England.

In the late 1970s, the National Spiritualist Association of Churches held its annual convention in Rochester. Some of the luminaries gathered in the lounge of the Crowne Plaza and toasted the essences of Maggie, Katie and Leah Fox with high spirits of another sort. Perhaps that is how you know Corinthian Hall once stood here.

THE REUNION INN

What *is* in a name? In this case, maybe plenty. In Rochester's boom days, people came from all over to buy valley land. Among them were the Massachusetts Bradstreets.

John Bradstreet (1711–74) had been a second colonel in the Massachusetts militia during the Imperial ("King George's") War (1739–47), the third of four French and Indian wars. Bradstreet admired his commander, Samuel Waldo, and the name stayed in the family. Samuel Waldo Bradstreet (1815–60) bought 177 lakeside acres and built the house we call the Reunion Inn (1854) on Culver Road.

White and squarish, with a cupola and four chimneys, the Reunion may look plain, but it is a fine example of early valley architecture and may have been a stop on the underground railroad. Samuel Bradstreet's time was cut short by a team of runaway horses, and in 1864, his home fell into a cycle of going through the decades as a hot potato. During Prohibition, it did a stint as a speakeasy. Even into the 1970s, old-timers at the Liquor Authority recalled the days of raids, busts and surveillance. Not until 1971, when its current owner acquired the home, did anyone keep it past the ten-year mark of builder Bradstreet. To this day, Jim Barnish remembers holding the title, amazed by the hands that had held it before him.

Another thing Barnish noticed is the growth of the Reunion's ghostly reputation. In the 1970s, a few employees reported ghosts or crazy physical tricks. At first, Barnish suspected their sobriety or sanity. He himself has never seen a ghost. But by 2008, many others have, and they stick to their stories. Word is out about the Reunion

The physical phenomena set everyone off. Trays fly off shelves, small objects move and voices in empty spaces bid, "Good morning." The place has several remarkable zones.

The basement's fieldstone walls hold one conspicuous, massive boulder that both psychics and historians speculate hides a burial. A co-owner

changing a keg on a cold December 1974 morning felt bony fingers grabbing his elbow. Alone and startled, he ran to the walk-in cooler and shut himself in. As his temperature lowered, his nerve grew, and he eventually bolted upstairs. He kept his own counsel for quite some time until a co-worker detailed the same experience.

Reunion ghosts tend to be unclear and unaware. They do their business until they fade or walk out of sight. An odd one appeared to a couple of patrons who were dining upstairs. Each claimed to have seen a woman in a gown—"peasant garb"—but they were looking in different directions. If valid, this report questions the nature of the witness experience. Either these were twin ghosts, or something directed one ghost to appear in the minds, not the eyes, of the observers.

A local media personality spent a night in the Reunion, and despite a few chilly moments, taped nothing out of the ordinary. But many photos taken to this day at the Reunion have orbs aplenty, including wispy lights and the occasional strange shadow.

People feel things here, too. Local mediums claim that nine people have died in the building and that their spirits are still here, including something ill-tempered in an upstairs storage room. A self-professed Spiritualist came to this space and reeled, shrieking: "Evil! Evil! Evil!" A psychic dreading spirits is a little like a carpenter despising wood, but the experience calls up images of that dingbat *Lost in Space* robot, 1960s version, wagging hoses and pincers. ("Danger! Danger, Will Robinson! Danger!") Neither fellow diners nor drama coaches shed tears when the woman fled.

Volcanic reactions are rare, but the Reunion's cachet seems on the rise. More and more people leave the inn sensing that something out of the norm has occurred. Most often they talk of little physical events like quick temperature shifts. It becomes a game just to experience—or imagine—them. The Reunion has been a Halloween-season destination for years.

Sometimes the supernatural impression is comforting. Some claim to catch pleasantly strange, almost forgotten scents as well: a loved one's favored perfume or aftershave, or a special flower dear to someone they once knew.

Think of the name: *Reunion*. This atmospheric inn has been the meeting place of friends for generations, and it may link the living and the dead. If conversation drifts to a friend or loved one who has passed on, stop and ask who else might be at your table.

THE POWERS THAT BE

One of Rochester's early movers and shakers was Daniel W. Powers (1818–97). Born in the small farming community of Batavia, Powers moved east with his family to a good place for an enterpriser, the budding city of Rochester. Young Powers started in hardware, flourished in banking and made it in war bonds. By the time of the Civil War, he was thinking about his own landmark, a business beacon for all corners of the region.

Even by Victorian standards, the Powers Building was opulent. Designed by A.J. Warner on the former site of the Eagle Hotel at 16 West Main Street, the five-story building loomed over the two-story city. It featured gas lighting, a sandstone façade and imported cast-iron décor. Built around a hollow square core, its interior feels curiously like a building within a building, or a reverse tower. Its fifty-ton, cast-iron staircase could have held most of Rochester's 1868 population.

The flagship of Powers's enterprises was equally as distinguished for its contents. By 1875, the largest private art gallery in the United States filled the fifth floor, housing a thousand pieces of original work and classic reproductions Powers had gathered in his trips to Europe.

Powers himself obsessed about his building and added three floors to keep it taller than the rising skyline and its new neighbor, the Wilder Building. When adding new levels became too cumbersome, Powers set a tower-like observation structure on top. It is still there today.

After Powers's death, the building declined. Only its fireproof status and its cast-iron skeleton kept it standing through the drafty vacancies. It is no wonder that it became a place of gloom.

By the late twentieth century, interest had turned to preserving Rochester's classics. Strange things were reported during the 1988 restoration of this big gem. Many security guards wouldn't go over the sixth floor at night because of unexplained events. Some who occupy it

today whisper about secret passages that Powers—or someone—designed into the building. And psychic phenomena continues. Elevators open and close their doors as if delivering spectral passengers. Appliances in some of the businesses likewise operate themselves. Indistinct figures turn up in photographs.

It is not easy to say who or what is responsible for the alleged psychic effects at the Powers Building. Gossip tends to seize upon people killed in the building's elevator, the first hydraulic one to be built upstate (1873). Deadly accidents in the neighboring Powers Hotel have become linked in the folklore. The grisliest was that of a Powers Hotel laundress, Annie Keitly, whose body may have been halved. Another we hear took place during the twentieth-century renovation.

Whoever it could be, some who work at the Powers Building sense someone still walking the marble floors. Could it be Daniel Powers gazing out from his office window on an unfamiliar skyline? Is it a laundress who haunts the scene of the death that shocked her?

MOTHER OF SORROWS

Because of its layers of meaning and tradition, this National Landmark in Rochester's northwestern suburb could be the area's most significant haunt.

The once-swampy land below Read's Corners (named for pioneer Nicholas Read) may have been a mystery zone long before its white settlers came. Some humanoid monstrosity may have been traditional to the area, possibly the Seneca child eater "High Hat." The first whites noticed what the Iroquois call "witch lights," ALP (Anomalous Light Phenomena) that could be many things but are fixtures at many haunts. Maybe it was a sign to the Irish settlers of the earthly spiritual energy present at so many places on their old sod. There is folklore about Little People here, too, though whether of the Irish or Iroquois variety may depend on the witness.

Where today's Latta Road and Mount Read Boulevard meet, Irish settlers, led by Felix McGuire, set up the first rural Roman Catholic church in New York State. The 1829 wooden "Church in the Woods" was dedicated to Saint Ambrose. The glorious Romanesque brick building we see today came in 1860. A host of tales have been drawn to the site.

Some tales that we hear about the Mother of Sorrows could come from the early days, including a pedestrian version of the vanishing hitchhiker. A pretty little girl woke the priest at an ungodly hour to confess her ill mother. She led him through darkened trails and fields, and then, matter-of-factly, disappeared near a tiny house. The venerable father was wondering if he had been led on a mission by a force the opposite of godly. He knocked on the door all the same, met the outwardly healthy woman and spotted a picture of his little tour guide. It was the woman's daughter, who had been dead for three years. Puzzled and suddenly very moved, the priest gave her confession and left. She died before morning.

Another tale involves a gentleman who tended the basement furnace every night so the church would be warm by morning. Many nights, at a

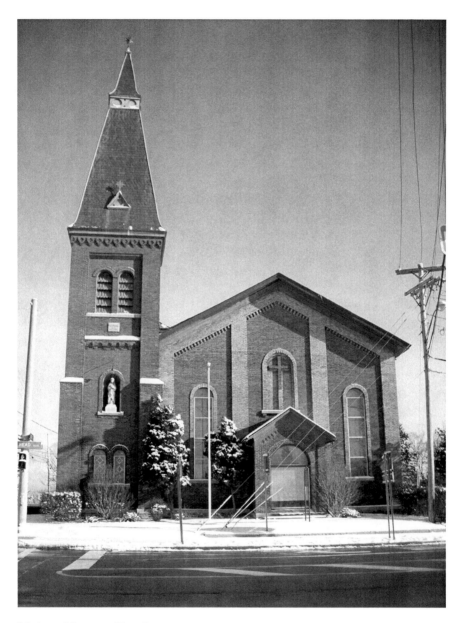

Mother of Sorrows Church.

regular hour, he heard footsteps above him. It was as if someone praying in the pews had walked to the altar. He always presumed it was the priest, but he had the feeling that it might have been something more unusual. One night, at the first sound of footsteps, he ran to the nearby rectory and found the priest in his study. The caretaker started tending the furnace an hour early so he could avoid the invisible walker.

In 1969, Mother of Sorrows Church became the Paddy Hill Library, noted several times by Husted in *Valley of the Ghosts*. On Halloween 1986, a *Rochester Times-Union* reporter did a little experiment in the church, accompanied by Husted and Spiritualist minister Lydia Samuel. While touring the former Mother of Sorrows, Samuel got impressions of several late priests whom Husted confirmed. Sensations of "repressed sorrow" seemed supported by the fact that this site had likely been a station on the underground railroad. Husted herself was shaken when Reverend Samuel caught the image of a girl killed in a fire—Husted's niece.

In 1993, local kids snuck out of a sleepover, walked around the library and got scared. They heard an invisible walker and a phantom bell. Through a dim window they saw spectral folk reading and socializing. Were these impressions from the church's past, including a phantom congregation? Other folklore suggests they are ghosts from the graveyard creeping up after dark, clanking pipes and creaking floors.

PITTSFORD

POWDER MILLS PARK

Irondequoit Creek meanders through a quaint county park in the eastern suburb of Pittsford. A tranquil place of hills, streams, trails and wetlands, Powder Mills once held a Seneca village. Fish and game were plentiful, and the valley around it provided anything necessary for Seneca life. Today, however, Powder Mills has a dark side. Its name and reputation as a haunted region come from its nineteenth-century past.

New Hampshireman Daniel Curtis Rand came to the Genesee and started a gunpowder manufacturing company in 1863. This part of Pittsford seemed a good fit, as it was isolated, far from any village, and near water power. Its quick elevation changes helped, too. Making black powder was tricky and dangerous. The hills and creeks here were natural barriers to the spread of fire between buildings.

Rand's mill gave the blasting force for many a Northeastern coal mine and supplemented the ammunition stores of the Union army in the War Between the States. At Daniel Rand's death, fourteen-year-old Philip Rand took over. It was about that time when the trouble started.

The most spectacular in a plague of calamities was a December 1887 explosion that sent much of the operation skyward and was felt in Avon, Canandaigua and Honeoye Falls. The gatekeeper at Hemlock Lake noticed the tremor in the water and phoned Rochester to ask what was going on. Who or what had triggered the blast? As with other accidents, the mill had been unmanned. Talk of a mystery saboteur, if not an outright curse, began to spread.

The mill closed around 1910. Twenty years later, Monroe County bought the land for a park. People frequented the area again, and reports gathered of a ghostly guest.

The dominant apparition of Powder Mills Park is a bearded man in nineteenth-century dress—an addled wanderer in need of help. People notice and even follow him, and sometimes as he's being tailed, he

vanishes. At other times, people report him simply appearing in the middle of a landscape.

Descriptions of his formation are interesting. It seems like he doesn't snap in, then out, as if controlled by a switch. It is more like this old rag-and-bone man simply forgets to stay where he is, wandering off into his own abstraction. Some think he could be one of the millworkers. Others, of course, in the pattern of folklore, suggest that the apparition is Daniel Curtis Rand, haunting his lost enterprise.

Powder Mills Park shares features with other haunted zones. For one thing, the limestone in this part of the valley is shot through with channels, some capacious like those under the village of Pittsford. Most tunnels are fraught with psychic rumor, whether or not people know they walk or dwell over them.

A spring that once nourished the trout beds here was big enough to get its own name—Beaver Meadows—and many of the ponds and streams we see at Powder Mills are sourced underground. This is a bit odd. Most of our streams are made by rainfall and runoff. Springs and natural fountains are not as common as we would expect. Not only is this water generated within the earth virtually worshipped by contemporary dowsers, but its sources are associated with apparitions, religious, psychic or paranormal. This includes, of course, ghosts, which some of today's dowsers feel directly correlate to issues of water flow.

What may figure just as strongly in the legends of Powder Mills Park, however, is a feature of the running water. In European folklore, waterways are thought to be barriers to all but the purest spirits, whether fairies, demons or the unsanctified dead. Fell supernaturals are thought to need human help to cross these symbolic thresholds. In many a tale and ballad, simply hopping a stream is enough to escape a pursuing entity. If we apply the motif to Powder Mills Park and its labyrinth of creeks and hills, we could have the case of a spirit trapped in its own prison. After years of explosions and changing water flows, the astral visitant may have lost his way out. Condemned to wander the labyrinth at Powder Mills, he comes to barriers he can't cross and simply vanishes.

THE GREEN LANTERN

Looming over the Erie Canal, Fairport's 1876 Green Lantern Inn is a head turner. The former home of Henry Addison DeLand was one of the finest examples in the Northeast of a style called Second Empire. Baking powder magnate DeLand (1834–1908) commissioned architect John Thomas to build a home as grand as his dreams.

Just after his virtual chateau was built, Deland took a Florida vacation—and stayed. In an undeveloped inland area between Daytona and Orlando, DeLand visualized the capital for education, culture and spirituality he was born a century too late to achieve on the Genesee River.

Upon Florida citrus, DeLand hoped to found his American Athens. He took out articles in New York papers hyping the business and the area. He lured settlers by guaranteeing the profitability of the orange fields. The zero-risk offer found takers. In 1883, he established the DeLand Academy, today's Stetson University. He gave land for a school, a church and a village, the last of which adopted his name. DeLand also founded the city of Lake Helen, naming it for his daughter.

A crop freeze in 1892 ravaged Florida, and DeLand's weather-dependent pitch put his own fortunes into a spin. He even lost the home in Fairport, and his last decades could not have been happy ones. Many others haunted in life are said to come back after. It should not surprise us if DeLand returns, at least in folklore.

A capitalist, visionary and village builder, DeLand reminds us of his upstate contemporary, East Aurora's Elbert Hubbard (1856–1915). As both ghost and community founder, Hubbard may be more famous due to his literary career and his association with the American arts and crafts movement. But the haunted profile is the same. It seems like anything DeLand built, occupied or frequented has some sort of ghost story today.

Psychic rumor turns up all over DeLand's old stomping grounds. DeLand historian Bill Dreggors remembers being ribbed by his wife for

making a continuous racket on the stairs of one of DeLand's homes. He had been working quietly upstairs all the time. He became a believer.

Curator Billy Desilva swears that the DeLand House Museum is haunted. He routinely encounters psychic physical activity in the familiar pattern: doors opening, lights operating themselves, cold spots. He never feels threatened, and he quite reasonably reflects that the haunting could be due to the town's settlers and not its namesake.

DeLand's Fairport home may be a meeting place for spirits. The full gamut of reports comes from current and former Green Lantern employees and guests: sounds, lights, apparitions.

It would be hasty to presume that all psychic phenomena in the Green Lantern Inn sprouts from founder DeLand. Several families owned the home in its first fifty years. Most of them appear in picture frames at today's inn, whose current name probably comes courtesy of Ethel Haight. A relative of one of these owners who planned to make it a bed-and-breakfast, she took one look at the front entrance and its stained-glass lanterns and the name came to her.

Bar, restaurant, inn. The Green Lantern has endured all of Rochester's ups and downs. How many generations did it mark? How many souls passed through its doors? How many return? The staff confirm the site as a supernatural powerhouse, a conference center for the deceased. One medium felt at least thirty spirits in the building. A hostess admittedly not "gifted in *that* way" is shocked by the number of others who, as soon as they walk in, notice *something.*

The kitchen staff believe in one presence in particular—a mischievous spirit who moves objects, causes mishaps, hides utensils and pulls other tricks in plain sight. It would make for an interesting live cooking show to say the least.

The Green Lantern's design may hold another clue. Architects note that the distinguishing features of Second Empire style include decorative porches and spires, a tower, a four-square floor plan, multiple chimneys and that curious *mansard* (steep-sided, flat-topped) roof. The fact that it was picked for a private residence may be part of the story.

Like the Christmas fruitcake nobody eats but that keeps getting sent as a gift, Second Empire buildings have the stereotype of being the houses that are nobody's homes. Many Second Empire structures that stand today are inns and offices. Perhaps ominously, many were built to be asylums. Greystone Park Psychiatric Hospital near Parsippany, New Jersey, and the vast Ohaio State Asylum for the Insane in Columbus are examples. The style could well have been chosen with a message we

would consider occult today. It was thought that those ill in mind or spirit could only recover in emotionally and physically nurturing environments. This involved geometric landscaping and churchy architecture. Second Empire sites are ghost magnets.

Barring unnatural cataclysms like "urban renewal," the Green Lantern will be there when you call. A bedrock wall—three feet thick—that would laugh at a California earthquake anchors the structure, and layers of brick keep what is built above it together.

VALENTOWN

Some buildings are haunted because of where they are, and others because of what comes into them. Valentown fits both bills.

The site should have energy. Not far away were major Seneca towns with burial grounds and sacred sites. Nearby Route 96 had been a major trail. Gannagaro was within strolling distance, and military artifacts were found nearby. This is Mormon country, too. Brigham Young made his farm here and brought the faith of the Latter Day Saints. We speak of the hamlet of Fishers and its resurrected museum, Valentown.

A crossroads village started here in 1809. By the end of the Civil War, the railroads were booming. One day in 1878, some railroad surveyors showed up on Levi Valentine's land and gave him the impression that a major line might be coming. (Pennsylvania coal had to reach Ontario ports somehow.) Filled with visions of a whole town, farmer Valentine started the rectangular wooden community center and shopping plaza, one of the first indoor shopping malls in the nation. Its name—Valentown—was a blend of Levi's name and that of his grandfather, Ichabod Town.

The railroad never made it to Levi's farm. The company bellied up, a common scenario in those wildcat days. Levi had a community center and no community. Valentown Hall hosted a variety of businesses: grocers, butchers, shoemakers, bakers, artists, actors, musicians and leatherworkers. The top floor was a ballroom. The basement was a stable.

Hard times knocked in 1940. Antiquarian, collector and lover of all things local, J. Sheldon Fisher opened the door. The Valentown Museum of Local History became Sheldon's life work. But first, an unpleasant surprise: local farmers had been storing their winter dead in the basement, waiting for the ground to soften. Now Valentown holds Sheldon's vast collection of artifacts and curios. Whatever feeds its mojo, the word is out. An array of psychic effects confronts the regulars.

A woman's voice has been heard calling, "Hello, hello!" as if looking for service. No one is there, of course, and no one could be. All nine doors are locked. A number of times people have heard chairs moving spontaneously. No one is sure if they really move or if this is just one more phantom sound effect. As if a breeze worked inside a glass case, the pages of a historical magazine turned and stopped on an article about 1861 events. Drawn by the sounds, the caretaker freaked. He had been folding an 1861 flag.

The south end of the second floor—nicknamed "the haberdashery"—may be a power zone. Sounds of breathing and an old-time music box have been reported here, as well as an apparition called "the dark shape." Sometimes preceded by a chill, it drifts diagonally up through the wall at the south end. The cameras of the TAPS (The Atlantic Paranormal Society) ghost-hunting crew caught something of the sort here.

The folks at Valentown host occasional ghost hunts. Whatever keeps the museum open preserves the cause of our old friend Sheldon. Adopted by the Senecas, mentored by the late Arthur Parker, seminal in the preservation of Gannagaro and vital in today's Ganondagan, his spirit is just one of the many that could be here.

HOUSE OF PAIN

G oodies for the teeth reached the Genesee Valley long before good dentistry. Even in the early twentieth century, dental care was rudimentary. One of Rochester's greatest knew this well.

George Eastman suffered quite a bit in his life from bad teeth. In middle age he got dentures from Harvey Burkhart, the most prominent dentist in the state. He was impressed with his cosmetic new teeth, but he wouldn't have needed them with good care in his youth. All around him, others were suffering. In 1915, Eastman sponsored a Rochester clinic bent on eradicating diseases of the nose, mouth and throat.

Once, places meant to heal the body were designed to uplift the spirit. Three prominent Rochester architects, who were fond of the churchy and monumental, were chosen to design Eastman's building. William Madden and Edwin S. Gordon had designed houses of worship in Rochester. Like-minded William Kaelber had worked on the Eastman Theater. Together they wrought the Eastman Dental building at 800 East Main Street. In October 1917, it opened under Dr. Burkhart himself.

Dedicated to the treatment of Rochester's children, Eastman Dental quickly became the top U.S. training school and a model for clinics everywhere. Countless children got their first care at this revolutionary facility. The immediate experience was painful. Anesthesia was primitive, and the teeth have a lot of nerves. Pain, blood and howling would have been common at this place bent on saving people from even worse.

Renamed the Eastman Dental Dispensary in 1941, it became the Eastman Dental Center in 1965. The center moved in 1979 into new buildings on the University of Rochester campus. Nothing moved into 800 East Main Street. The fine Italian Renaissance-style dispensary suffered years of neglect and was added to the list of endangered structures in New York State.

So often, trauma is associated with sites that develop psychic folklore. It is not uncommon, either, in big, drafty buildings, especially ones that

have experienced on and off vacancy. It shouldn't surprise us that workers and guests in the former dispensary have reported voices in empty space and the occasional push from invisible pranksters. People strolling on East Avenue have seen lights coursing through the empty halls.

In fall 2007, an enterprising company remodeled part of the dispensary for a hall of horrors. Even with actors, costumes, props and sound effects, the chills at the "House of Pain" were not all contrived. The crew found the building to be active with apparitions and sounds.

Two local ghost hunting outfits were brought in that season. They found activity, as they always seem to, in big, creepy buildings. They may have taped EVPs (electronic voice phenomena) and photographed orbs, which they also reported seeing. Both squads endured strange electrical breakdowns, including fresh camera and flashlight batteries that died in one hall and worked again soon after elsewhere. Psychics refused to enter some areas of the dispensary and reported their hands being pulled, as if by invisible children.

This is one of the few sites or incidents in our book "validated" by investigation. This will impress you if you think a building can be proved haunted by any means, and if it doesn't strike you as unlikely that "ghosts" act up just as they're being stalked.

It would still be interesting to know more about the parts of the building in which these phantom feelers were sensed, the incidents in time to which they could be reacting, the directions in which people were being pulled and the histories of the spots from which, or to which, they were being led.

ROCHESTER

THE DINOSAUR

As of 2008, the Dinosaur Bar-B-Cue at 99 Court Street is a restaurant pub known for funky décor, live music and ample servings. A former train depot of the Lehigh Valley Railroad, it is on the National Register of Historic Places and is in proximity to another of our haunts, the Rundel Library. It is bandied about that a Seneca village may have been on the spot just south of the Court Street bridge on the east side of the Genesee River.

The style of the 1905 core is, in shorthand, Gothic revival, with qualities from other sources—arts and crafts and art deco. Builder/designer F.D. Hyde may not be one of the top names in United States or even local architecture, but he beats the heck out of those who design your typical strip mall.

Someone named F.D. Hyde designed an 1886 addition to a school in Dubuque, Iowa. An F.D. Hyde picked up a coin for a man on crutches (1913) at a Chicago train station and found himself missing an envelope that held personal papers, receipts from his Chicago hotel and $1,500. Before heading, crestfallen, back to New York, he asked his hotel if anything had been left for him. Sure enough, the envelope and his papers were there. A chivalrous cutpurse still held the money.

Hyde's company seems to have designed tricky train stations like one in Summit, New Jersey, styled a bit like Rochester's Dinosaur but sub-street level. The former Lehigh Valley Railroad Station was even trickier, held over the Genesee River by steel beams. The track under it hasn't been active since 1950. The city bought the depot in 1954, but it stayed empty for decades. The small, thematic Dinosaur franchise arrived in 2003 and did some remodeling, but the tunnels are still there—a voluminous underground in which hordes of homeless may dwell.

We'll talk soon about the superstition of trains and tracks. We should think about the station as a hub of passing humanity with a propensity

to draw psychic folklore. A little like the communal-stranger culture of a school or hospital, these nodes of gathering folks hold for only a little while and then disperse. It is a metaphor for life in the world.

The staff at today's Dinosaur tell stories, one of our favorites being "the phantom train." Now and then someone hears a surging, rhythmic gathering and senses a train is coming. Only when the sound, vast in its world, never crests do the witnesses catch themselves, realizing that no train ever runs here. "It blows my mind every time!" said a hostess.

Inns and restaurants offer countless opportunities for real or imagined SPOTUK. So proverbial is the Dinosaur poltergeist that the staff even named the elf Charlie.

The most dramatic tales involve a little girl ghost. She appears unaccountably and solo in some parts of the building, only to disappear. Could she have roots in the site's past as a station? Could the living girl whose image she carries have been there decades before?

We know how common these little girl ghosts are, of course, but this or another form of her in the Dinosaur has the earmarks of another apparition, the vanishing hitchhiker—a routine story at the Dinosaur. Our favorite version involves her seated at a table with an adult couple so naturally that the waitress pours water for three. As she fills the last glass, she looks up to find the two staring at her. The girl is gone.

When an out-of-breath rookie relates the encounter, a weary chorus finishes her description: "White dress, blue flowers."

"Gotcha!" a waitress chimes in.

"Gets me every time," says the manager.

ARCHITECT OF THE OCCULT

Some think city namesake Nathaniel Rochester had his house at the northeast corner of Spring and South Washington Streets. If it had a cupola, he could have looked across the Genesee River. Smack dab on the spot today is an exotic brick-and-tile building with a legacy of its own.

It is called the Bevier (*Bevy-YAY*) Memorial Building, after Susan Bevier, another Rochester benefactor. It was built in 1908 for the Rochester Athenaeum and Mechanics Institute, a predecessor of today's thriving Rochester Institute of Technology. It has had a number of tenants since RIT's 1968 relocation, enduring spells of vacancy and the recent fall of one heavy overhang. The Bevier was a personal favorite of its designer, an overlooked Rochester polymath.

Author, artist, architect and playwright Claude Fayette Bragdon (1866–1946) was born in Oberlin, Ohio. His father was that odd combination of poet and newspaper editor, meaning his kids grew up artsy but moved a lot. After an upstate childhood in Watertown, Dansville and Oswego, Bragdon worked in a Rochester architect's office and then as a cartoonist. From the latter, he was canned for taking too sharp a pen to prime citizen Daniel Powers.

But everyone knew that he had talent. By 1890, Bragdon landed with Buffalo architectural firm Green and Wicks. His hand was in on some stellar Queen City buildings. By 1896, he was back in Rochester designing houses, churches and city buildings, and running a press brazenly devoted to his Theosophical convictions. (Hip but against the mainstream, Theosophy was a spiritualistic morph of world traditions, including Hindu and Tibetan.)

Bragdon comes off as fickle. Elbert Hubbard of Roycroft featured his work at a time when Bragdon needed a break. When his own star was higher, Bragdon had no time for Hubbard. A Theosophist should have gotten along better with a mystic. Though Hubbard never committed to

any single outfit but the Rosicrucians, many of his friends and idols were Theosophists: poet Ella Wheeler Wilcox; poet and architect Theodate Pope; "Golden Dawn" founder H.P. Blavatsky; and "Golden Dawn" leader Annie Besant. Bragdon's real feat was to offend George Eastman in 1918 over the design of the chamber of commerce building. There was no point in looking for high-end architecture work in the Flower City after that.

Bragdon did a few buildings in Canada, but he seems to have fallen more into theater arts, including set design. By 1923, he was in New York City settling into life as an author, critic and socialite—another Bragdon paradox. No one is suggesting that the arts lack elitism; it's just that in the last few centuries, artists don't think of themselves as *aristocratic* elites. They're...proletarian ones. But this is the hardest side of Bragdon to get around, and something that, with his deuced tendency to clash with clout, may have subdued his legacy.

Bragdon stayed true, though, to his stylistic roots and his mystical leanings. Having come of age when the arts and crafts movement was hot, Bragdon did wonderful work in many media. His drawings and calligraphy are reminiscent of Dard Hunter, William Morris and Frank Lloyd Wright. His buildings remind us of the man Wright called "the master," Louis Sullivan, with maybe a touch of H.H. Richardson. And his books: Bragdon's ideas of world, spirit, people and nature are so abstruse that it is hard to see how his structures directly embody them. He is a little like Frank Lloyd Wright in that way, or a great jazz solo—you sense there's a pattern to what you hear, but visualizing it is beyond you.

A Rochester developer bought Bragdon's career masterpiece, the New York Central Railroad Station, in 1965 and demolished it step by wretched step. Only a few of Bragdon's works in his home city have survived neglect, renewal and such "development," among them the First Universalist Church on Clinton Street, the Chamber of Commerce Building and the Bevier. Any one would be a good place to go ghost hunting.

Ghost stories follow any whiff of occultism, and Bragdon leaves us a bouquet. Someone who specializes in symbolism could probably look the Bevier over and give you quite a rundown. One who knows sacred architecture could write a book. The so-far obtainable psychic rumors come third hand. Architects who worked here complained to their fellows that the Bevier was active with the full package. Doors worked themselves. Things sounded off. Neighborhood garage workers saw strange lights in the building when it should have been dark. So far, though, we have heard nothing of Bragdon as a ghost. We would have loved to have had that to tell you and thus bring him back, even imaginatively.

OF OWLS AND ARCHITECTURE

The lodges and fields of a nine-acre Algonkian settlement were the site of today's University of Rochester River Campus, just downhill from the glorious Mount Hope Cemetery. It is hard to tell how great an influence either might have on the ghost stories at the 1927 Rush Rhees Library.

All colleges have a haunted building. This one, named for the institution's third president, is spectacular. As if symbolic that a library would be the dominant campus building, the 186-foot tower looms over the valley. The Hopeman carillon inside it is the biggest musical instrument in Rochester. Its tones permeate the campus.

This exquisitely classical library holds mystery. Its nooks, crannies and reliefs nurture the imagination. Its high locations have spectacular views of the valley, and its highest (it is asserted) may have played some role in CIA training, possibly even psychokinetic and remote viewing experiments. (Glad we're not the only ones who think it's got power!)

The most significant ornaments at "the Rush" may be stone owls on the tower and cornices. Traditional images at many libraries, owls symbolize wisdom. They were featured on the shield of Greek war-and-wisdom goddess Athena. They may hold more primitive suggestions. For many world cultures, these winged hunters that see through the dark also see spirits and destiny. They are harbingers of death. But the hauntings at Rush Rhees may be attributable to more than architecture or owls. A construction accident is campus legend.

Young Sicilian immigrant Pete Nicosia fell 150 feet to his death in 1929. His foreman, James Conroy, saw to his burial arrangements. Far from family and home—the foundation sacrifice—he may still be looking for company in the stacks and tower he helped build. During a fifteen-year period (1933–48), students and staff made reports of an apparition wearing overalls and an old-timey sweater. It looked like Nicosia should have.

The Rush Rhees Library on the University of Rochester campus.

More recent reports—evidently those of psychics—are more detailed. To them, this ghost introduces himself as "Pete," claims his death was painless, asks for his foreman, whines about not being paid and admits he'd like to appear on the front page of the paper. Even death, it seems, doesn't quell that desire for the power quarter hour, the proverbial fifteen minutes of fame.

The Rush Rhees Library is far more than the sum of the knowledge it holds. If you meet a spectral young man in work clothes in one of its darkened halls, say hello to Peter for us.

THE RUNDEL MEMORIAL

In a 1986 article, Blake McKelvey noted something curious about the early Genesee Valley. The first two public buildings in each town were a school and a church. The third was often some sort of reading room. Life was tough for the pioneers, but books helped them through it.

By the mid-1800s, many "social libraries"—literary clubs—had formed. Some have been exceptionally long-lived, and they provide for one of Rochester's more remarkable legacies.

Out of a Union College fraternity shot the heady clique called generally "the Club" (1854), an offshoot of the interests of Lewis Henry Morgan, the great scholar of Iroquoia. Its membership froze at seventeen lustrous educators, clergymen and barristers. The men's wives nicknamed it "the Pundit Club," as it is better remembered. The Pundits were followed by others, including the Shakespeare Club (1865), the Spencer Club (1872) and the Browning Club (1884). Distinguished Victorian-era men in these clubs included Dr. Augustus Strong, Reverend Algernon Crapsey (poet Adelaide's father), university president Rush Rhees, minister-reformer William Gannett and author-architect Claude Bragdon.

But this is the Genesee Valley, and women certainly couldn't be left out. One of the first of the women's clubs was Jane Marsh Parker's wry Ignorance Club (1880). The Roundabout Club (1885) soon followed. The Tuesday Reading Club, the Wednesday Club and the American History Class all came into being in 1890. One club, founded in 1897 as the Reading Club and soon after called Hakkoreoth (Hebrew for "readers"), was active last we heard. These clubs were the antecedents of the public library system.

One of the first more-or-less public book halls was that of the Athenaeum, housed from 1849 to 1871 in the previously discussed Corinthian Hall. By the twentieth century, awareness was building that Rochester needed a single, central library. A solution came in a typical way for Rochester: through a benefactor.

A wealthy, accomplished, modest bachelor, Morton Rundel (1838–1911), had a lot in common with other great valley givers like George Eastman and William Pryor Letchworth. Born in Alexander just south of Batavia, Rundel was Eastman's first cousin and lifelong fishing partner. It may have been this that caused Rundel to hold on to his shares in Eastman's company through the tough times. It may also have been the advice he got from a medium. Like many valley folk, he had a curiosity about life on the other side.

The trust Rundel left for the library building went unused for two decades and grew substantially. Rundel's heirs sued, since it seemed like no one was planning to use it for a library. The government decided it got to keep the money, but used it as intended.

Architects we've met before in this book—Edwin Gordon and William Kaelber—designed the Rundel Memorial Building holding today's Central Library. The blocky Rundel is festooned with mottoes, inscriptions and symbolic figures. It has been described as a twentieth-century Renaissance-style building, but it reminds us of Washington, D.C.'s classical Folger Shakespeare Library.

A number of sites had been considered, but the one that was picked on the east bank of the Genesee River had a rich legacy. In 1817, when "Rochesterville" had just over a thousand inhabitants, Elisha Johnson and Orson Seymour had cut a "race"—a sort of fake creek—here to operate a mill, one of seventy that would be around in ten years. The Erie Canal met the Genesee here, too, and the Erie Canal Aqueduct—a mighty, water-filled bridge—carried barges right over the river. When the canal was abandoned in the 1920s, subway trains took its place on the original bed. Until 1956, they ran like the waters pouring into the Genesee under today's Rundel—organically incorporated into its siting almost like a work of Frank Lloyd Wright. It may be energetic in other senses as well.

Some who work in the Rundel confirm the shadows, sensations, voices and phenomena that go with the general picture of an active site. The building is voluminous, and the sense of co-walkers might be natural. The hottest areas may be the lower stacks. An interesting detail comes from the local history room on the second floor, in the southeast corner. On many nights, security guards notice an inexplicable light effect on the surveillance cameras, as if a little Tinkerbell auditions here as a star of light. If this effect is valid, to what book, object or document could it be reacting?

FIELD OF SPIRITS

Our taste in haunted sites tends to run toward ones with meaning in layers. We like the traditional and folkloric. It should not be forgotten, however, that there is no absolute profile to haunted sites other than the presence of supernaturally tinged gossip. It is not just old forts and Victorian mansions; sometimes it is the new and glitzy. Enter a haunted baseball park.

It is not rare for sport to be mythologized. Think of the Greeks with their Olympics, the Celts with their hurling, the Mayans with their ball game and the Iroquois with their lacrosse. From *It Happens Every Spring* to *Field of Dreams,* baseball has been supernaturalized like no other American sport. There could be reasons for that. Baseball is the oldest "everyman" sport in the United States. It has been big enough for long enough to have the aura of the classic. But the capacity for folklore at Frontier Field could be related specifically to the site.

One of the classic minor league parks in the United States was the original Silver Stadium (1929–96) in northern Rochester on the west side of the Genesee River. The Silver seated eleven thousand people and was an easy place to watch a game. Almost every seat was sheltered and close to the action, and its quaint light fixtures recalled another era. By the 1990s, it was resolved that a new stadium was needed. In the midst of some controversy, aging Silver Stadium was flattened for an office park. By 1996, Frontier Field was built a few blocks to the south.

Though Frontier Field at 1 Morrie Silver Way was built for baseball, it has housed teams in other sports, including the Rochester Raging Rhinos (soccer) and the Rochester Rattlers (lacrosse). The Rochester Red Wings (baseball) of the International League have held court here since 1997. Now named for the prime telephone company in Rochester, Frontier Field seats eleven thousand spectators, exclusively for baseball.

It should not surprise us if there are ghost stories about Frontier Field. Other mass-recreational areas of Western New York collect supernatural

rumor. Ralph Wilson Stadium in Orchard Park and Six Flags/Darien Lake in Darien stand out. ESPN reporter Don Barone caught wind of the stories at Frontier Field and came for a tour in 2005. Four members of Rochester Paranormal Investigations led Barone about the stadium for an on-camera investigation.

While a lighthearted moment for the writer, it was a pressure one for the investigating team. Rochester Paranormal was game, however, and even did a little ritual hoping to call up some presences. Happy to meet people who could see them, they flocked about psychic medium Cindy Lee. "Oh, don't you just love it here?" they said to her. "It's such a great place. Oh, have you seen any of the baseball yet? We get to watch all the games for free."

Mysterious mists called "ectoplasm" turned up on photographs taken of the night, with faint impressions of faces and bio-forms. Some were more interesting than others we've seen, including one of someone in a baseball hat. Maybe the place is haunted.

The Red Wings' front office staff may be leery of the talk. Grounds personnel are a different story. Some recall hearing psychic voices on many occasions and experiencing electrical tricks. For example, a television that had not been used for a month decided to turn itself on in plain view of staff members. Others report impressions that could be psychic, including simple uneasy feelings. Some recall that bones—presumably human— were uncovered during construction at the field.

At the time of the interview, the Red Wings hadn't been doing a lot of winning, and consensus was building that the field or the team may have been cursed. Talk to people in Buffalo about a curse.

PHANTOMS
OF THE FAMOUS

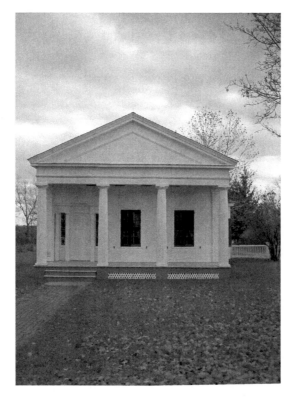

The childhood home of photography revolutionary
George Eastman.

THE GEORGE WASHINGTON EFFECT

All ghost reports seem folkloric to many of us, but some patterns have a curious integrity. With few exceptions, the ghosts that eyewitnesses claim to see are seen nowhere else. Ghosts of folklore are a different story. Famous people may have many ghosts. I call this "the George Washington Effect."

There are "George Washington" ghosts all over the original colonies, anywhere he was known to have been. At talks and tours, I like to joke that if there is an outhouse standing in one of the first thirteen states with the slightest psychic rumor to it, the folklore fingers Honest George. I guess this is natural.

Folklore loves the dramatic and momentous: famous people, places and events. At any site or building that develops psychic rumor, the tellers of the tale will pick the most famous stiff that ever had any association with the place and decide that is who the ghost must be. This section is about a few historic personalities who come back to Sweet Valley.

Two Voices Falling

Rumors spread about the blonde, striking girl who had been spotted among the Senecas. Was she a freak, an albino, a ghost, an illusion? When the whites moved into the valley for good, it was found that she was a living woman, and one whose saga would figure in the frontier history of the Genesee Valley. Her benign, buckskinned image in bronze looks down today from its pedestal in Letchworth State Park, the last resting place of "the White Woman of the Genesee."

As befits one who would bridge two cultures, Mary Jemison (1743–1833) was born between the continents. Her parents were aboard the *William and Mary*, en route to Philadelphia from Ireland. The family left the coast and settled near Gettysburg, Pennsylvania. In those years, it took a lot of gumption to go anywhere in North America.

Danger lurked outside the inland villages. The roads were only foot trails and cart paths. Native American nations were not all at peace with their new neighbors. Renegades, outlaws and natural predators—bears, lions and wolves—made night travel unthinkable. It was also an era of political turmoil. Wars for a continent were being fought between two great European powers. Native allies campaigning for France or England did so for prisoners, spoils and scalps.

In 1758, the home of Thomas and Jane Jemison was attacked by four Frenchmen and six Shawnees. The family members were taken on a horrific march and all but one of them were killed. Mary may have been saved by her looks. After reaching Fort Duquesne (modern-day Pittsburgh) she was sold to some Senecas who took her to their village, where she was adopted and named Dehgewanus ("Two Voices Falling"). She married a Delaware named Sheninjee.

When the French and Indian Wars were over, all white captives were supposed to be returned. But Mary Jemison had developed a love for the Senecas and asked to stay with them. Concerned that they might be

parted, she and her husband fled to the Sehgehunda Valley by the Middle Falls of the Genesee River. Sheninjee died of illness, and Mary took her memorable second husband, the Seneca war chief Hiakatoo. (Though kind and moderate with his family, Hiakatoo made an NFL linebacker look tame.) They settled near the Gardeau Flats in today's Letchworth State Park. There, Mary lived until she sold the land in 1831 and moved to the Buffalo Creek Reservation.

Jemison saw tragedy in her life. She was often needy, and keeping a frontier homestead was a backbreaking lifestyle. Her family also suffered from the white man's disease—alcoholism. Three of her sons met untimely ends due to some connection to the liquid plague. Mary Jemison was even accused of witchcraft, and on several occasions she hid in the woods until the heat had passed.

Today, Mary Jemison is an esteemed figure among the Senecas, and many descendants bear her name. How serious could the accusations against her have been? Our Seneca friends just shrug. A witchcraft charge was a great way to get rid of a rival. Some illustrious Iroquois—including Red Jacket—were similarly accused. It is also not unheard of for whites to dabble in the Dark Arts, or to at least gain reputations for doing so. In the early twentieth century, on the Tonawanda Reservation, it was widely thought that a longtime white physician had a lot of "medicine." "Maybe she just tried a little too hard to be Indian [sic]," was the conclusion of one of our Seneca friends about Mary. Her witch-son John learned what he knew from somewhere.

On September 19, 1833, the spirit of the White Woman of the Genesee passed into the next world. What remained of her in this one was buried near Seneca statesman Red Jacket on the Buffalo Creek Reservation, in land that would become today's Buffum Street Cemetery. This sheltered lot near the southern entrance to Frederick Law Olmsted's Cazenovia Park in Buffalo hosts not only an ancient burial mound, but also a legion of ghost stories, none outwardly related to its famous earlier tenants. Mary Jemison's remains were returned to her beloved valley near the site of her home. Her bronze monument went up on William Pryor Letchworth's estate in 1910.

Ghostly folklore gravitates to the famous. Add a waft of witchcraft and a displaced grave, and it is no wonder that there would be a century of tradition about the White Woman of the Genesee. "Women in White" are common ghostly forms, of course, and the ones in this part of Letchworth are usually associated with Jemison.

The Supernatural History of the Lower Genesee

Over the years, visitors to Letchworth State Park have reported other apparitions. From the overlook, people have seen a short, columnar mist move about the Gardeau Flats at the river's edge as deliberately as if it lived. It disappears as it nears the tree line.

A broad-minded local historian has three possible explanations for this. The most natural theory is that it could be ground fog drifting in the breezes of the river valley. It could also be a different ghost. There is the legend of a young Seneca bride who perished with her child in the cataracts of the nearby Genesee. Their bodies were never recovered and their ghosts are said to wander the river's edge. Finally, it could indeed be Mary Jemison wandering what once was her home. A bond to a beloved location holds a strong psychic connection. For some who have seen or heard about these apparitions, there is little doubt that "the White Woman of the Genesee" still walks the old trails.

To Drive Like Hell

B y 2008, the subject seems old. But many readers of this book will be strangers to the region, and you can't write a book about the valley's famous ghosts and leave out one of its most famous ghosts. Meet the Jimmy Hoffa of his century: the Murdered Mason.

Quite a scandal in its day, the William Morgan case was forgotten by the average upstater in a few decades. Our mid-twentieth-century forbears in upstate folklore and history, including Carl Carmer and Arch Merrill, brought the man and his strange story to light again.

William Morgan (1774–1826?) of Culpepper, Virginia, settled in Western New York after the War of 1812. By the time the saga that became legend began, he was a forty-four-year-old husband and father in Batavia, New York. Little else is agreed upon.

He may have been the War of 1812 captain he claimed to have been, and he may not even have been a veteran. He may have tried being a brewer, but it is certain that he worked in a Rochester quarry. He was also a diffident provider. As his second child was born in Batavia, he frolicked in a Canandaigua pub. Innkeepers in Batavia and Canandaigua portrayed him as a hard-drinking gambler kicked out of a Masonic lodge for alcoholism. By 1825, Morgan's snoot was in a toot over some slight from the Masons, and he was writing a book on the order. Some of his acquaintances decided to be publishers, and local citizens who happened to be Masons didn't like the scenario one bit. They turned vigilante.

Sometime in mid-September 1826, Morgan was accused of something trivial by a bunch of Freemasons, hauled into court, jailed, bailed and then kidnapped, at which point he vanished from history. These are about the only details upon which everyone agrees. The rest is hearsay.

To say that residents of the Genesee Valley went up in arms would be little overstatement. The extent to which the whole young nation was involved is the mystery, doubtless one that shocked the Freemasons. A

long, public series of trials saw the whole affair laid out, to the extent anyone believed anything that was said. ("Somebody told me to drive like hell," testified the driver of the coach, "for there was a man inside who was bound for that place.")

A few things seem likely. Morgan was taken—more or less against his will, depending on the state of intoxication—through Rochester, along the natural prehistoric highway of the Ridge Road, through Lewiston and eventually Youngstown. He probably was held for a few days at Fort Niagara, which was then run, like so much else, by a Freemason. He probably was killed and pitched into Lake Ontario, or simply pitched into Lake Ontario. He could also have been bought off and sent to remote regions in Canada or even off the continent.

Clearly, the local Freemasons wanted to protect something. Concepts like "the Masonic Secret" draw to other occult societies. But if Morgan even was a Freemason, he was not one in good standing, and his authority to know anything on a larger scale is in question. Some speculate that if he had anything at all on the Masons, it involved political and economic indiscretions. Most prominent upstate men at this time were of the lodge, and collusion was not out of the question.

When *Illuminations of Freemasonry* finally came out, it held almost no new information. Its tricky symbols and handshakes had been public for at least a century. It was probably copped from earlier sources, and even worse, it was poorly written. ("A more absolutely inconsequential mess of rubbish was never printed and bound," wrote the comically sour E.W. Vanderhoof.)

The Morgan affair touched a nerve in the American public. People have never liked parties that didn't invite them, and there had been centuries of suspicion in Europe about secret groups. Templars, Cathars, Rosicrucians and Illuminati, among others, were the subjects of suspicion, mythology and even repression. (See *Shadows of the Western Door* [1997] for a compressed summary.) We should probably include with this the witch hysteria that touched the young United States. And it wasn't over.

In 1828, the first convention of anti-Masons was held in Leroy, New York. This first American third party held a convention at Utica and promoted candidates bent on taking the world back from Freemasonry. New York Governor DeWitt Clinton and U.S. President Millard Fillmore started their public lives in "the Antimasonic Party." Not until the time of the Civil War did the nation move completely beyond anti-Masonry.

Scandals are often linked to psychic rumor. Not only did the living Morgan have a penchant for getting mixed up with trouble—remember the "Faded Coat of Blue" in this book—but anything touching upon

the Freemasons leads to a web of speculation. The Iroquois and the Masons were thought to share ties, and there is talk that Morgan may have been quartered for a few years among the Senecas of the Tonawanda Reservation, where he died of natural—maybe liquid—causes. Near-neighbor and Mormon founder Joseph Smith was fascinated by occultism of any type, and his name comes into the Morgan mess. Morgan's widow Lucinda ended up as one of Smith's wives.

Morgan himself makes a gregarious ghost. His image—or apparitions that folklore attributes to him—are reported at many points along his ride to judgment. They include sites in Batavia, a courthouse in Canandaigua, an inn in Lewiston and a fort in Youngstown. In this sense, Morgan is the traveling salesman of upstate ghosts. And no wonder. It was said that

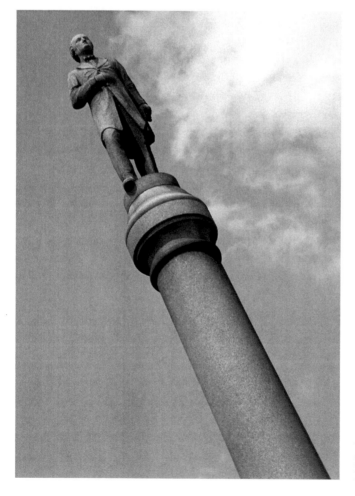

The "Murdered Mason," William Morgan.

Morgan's caravan stopped at every pub along his "Highway to Hell." It would have been an agreeable way to keep him riding.

At some of the sites—Fort Niagara and the Frontier House in Lewiston—the convivial apparition introduces itself as the murdered Mason. The black-curtained coach in which Morgan took his last ride, or some such vehicular apparition, has been spotted at points along the Ridge Road—Route 104—and at places in old Rochester. A boulder at a haunted Niagara County estate was said to be the stone that anchored Morgan on his one-way, deep dive into the Ontario. (How it got to an Olcott lawn is left to the imagination.) Psychic phenomena attributed to this affair include even a fine necklace of discolored fleece—red, it is said—on the necks of lambs born in the spring of 1827.

We haven't heard of any sightings of anything even delusionally suspected of being Morgan since the 1970s. The coach may not have been spotted for decades before that. And whether these were all Morgan's ghosts, people would know what he should look like. That soaring pillar over the Batavia cemetery can be spotted a long way off. Now, if someone would get working on the statue of that damn coach, we'd have it all covered.

THE LADY AND THE TRACKS

The rails between Canandaigua and Rochester were home to one of the most memorable local figures of the nineteenth century, and one who made a remarkable ghost.

Twenty-first-century folks can't appreciate the wonder the old-timers must have felt looking at train tracks. Those silvery, never-converging bars must have seemed the pathways to all the possibility in the world. There they were: tantalizing, in plain sight. One could even touch them and sense their power! They led out of the here and now and into a never-realized future.

There was also superstition. Trains had accidents. The trepidation and sense of fate some of us attach to airplanes was projected onto those rails. It may be no wonder that at least a few of the stations in Western New York are built with church-style architecture. As if to lay a blessing on those leaving or arriving, stations in Medina and East Aurora are wrought into cruciform shapes.

To the Native Americans, this sense of dread was understandable. The Iroquois thought the whites were crazy, laying roads, canals and tracks from point to point along a map, concerned only with moving people and products across the landscape. "You don't know what you're messing with," an elder told us. "You don't know what you're turning up." The Iroquois "witch lights" often move along train tracks.

Around 1801, Eliza O'Brien was born by the railroad to a successful Canandaigua family. She led a normal enough life. Big-boned and strong, it is said, she wasn't real ladylike.

Around the time of the Civil War, Eliza caught the eye of a handy buck getting off a diamond-stack locomotive. He called himself O'Brien. Soon after he and Eliza were married, he ran away with a chunk of her money, doubtless along the tracks by which they had met. Eliza O'Brien hurled herself down the rails after him. Lucky for him, she never found

him. After a few months or years, Eliza came back to Canandaigua, her anger no longer concentrated just on the man who had jilted her.

Some of Eliza's ideas had company in mid-1800s Western New York, but she went a lot farther than most who wanted simple equality. She made man-hating a lifestyle. To women's groups she gave speeches on the "perfidiousness of men." She haunted schoolyards and pulled girls aside with the same message. She didn't talk to men unless she had to. She avoided restaurants with male cooks. She wouldn't ride trains because engineers were men. She walked a lot of places, a predilection making her the woman the public knew and stamping her image on the landscape. We can see her still, a female Lear in hoop skirts, trudging through the storms along those bare, broad highways.

Even among the men she despised, there was sympathy for Eliza. Many a time along the tracks she stalked, a household took her in for food and shelter. Many a host passed the potatoes as she sounded off to his children about his gender. The community of Fishers became a second home. The railroaders, though, were suspicious of Eliza, as if she could hex them. They were afraid to cross her. Eliza—or the form of some other old woman running on the tracks—was suspected of opening a switch and causing at least one accident near Fishers. It would not be the first time occult rumors swirled around women who lived on the edges of society.

In June 1896, Eliza of the Track Ways was laid to rest in St. Mary's (now Calvary) Catholic Cemetery in Canandaigua. That life had to be hard, but it may have kept her hale. That was a lot of Western New York winters through which to be marching along the rails.

While memories of the living Eliza were strong, apparitions of the track ways one could be good omens, even protectors. A remarkable story comes from a howling night at the turn of the century. The conductor of a passenger train spotted something on the tracks ahead. As the train caught up, its form became clear: a woman in hoop skirts and old-timey clothing. The engineer blasted the whistle. Why wouldn't she just jump off the tracks? And something was unnatural about her. How could a human run so far so fast? Still, she was losing this race. The engineer stopped the train and ran out onto wet and empty tracks and discovered another marvel: a titanic washout over Irondequoit Creek. Hundreds of Irish immigrants had been saved.

But sometimes the fell spirit returns, at least as a prankster. One summer night in 1918, a train rested in Fishers. As its crew dined, the train decided to take off, without explanation. It ran out of steam near the Pittsford canal. A witness reported an old woman dilly-dallying near the engine before the commotion started.

That same season, the First World War raged in Europe. Troop trains ran through the Genesee Valley, and tracks were patrolled against saboteurs. The guards along Eliza's old haunts were jumpy. Several times, those posted near Auburn challenged a dark figure who appeared under a bridge and then vanished. Shots were fired at least once. All sensed it was Eliza, the feminist trickster, at work.

Today, some of the lines Eliza hiked are recreation paths, and sightings of her have slowed. Then again, there is talk of her resurfacing to work security at the 1999 Lilith Fair as it swung into Canandaigua. She may still be a roadie with Melissa Etheridge.

THE DOUGLASS HOUSE

Rochester's legacy as a home of alternative ideas helps explain the sojourn of a famous American. One of the most illustrious voices ever raised against slavery came into the world with a howl in 1818 on the eastern shore of Maryland. Frederick Augustus Washington Bailey may have been part white, but he took the last name of his slave mother, Harriet. The man we would eventually know as Frederick Douglass renamed himself for a character in Scott's *Lady of the Lake* and led one of the most remarkable lives of the nineteenth century.

To cut a fine saga brutally short, Douglass escaped from slavery and became an abolitionist, a publisher, a public servant and an international celebrity. Via the underground railroad, which was so prominent in the Genesee Valley, Douglass helped hundreds to freedom. He knew many of the leaders of his day, but his closest contact was with abolitionists and social reformers, including Elizabeth Cady Stanton, William Lloyd Garrison, John Brown and Susan B. Anthony. The Flower City grew to admire his abolitionist paper *North Star*, whose motto would not be out of place today: "Right is of no sex—Truth is of no color—God is the Father of us all, and we are all Brethren." A statue of Douglass—the first in the nation to honor a black American—was erected here in 1899.

Twenty-five of Douglass's prime years were spent in Rochester. "I shall always feel more at home (there)...than anywhere else in the country," he wrote. Maybe that explains the modest, two-story house on Hamilton Street, close to the river and near I-490.

Douglass owned other Rochester buildings in which he may not have lived. Most of them are no longer standing. The house on Hamilton Street was owned by Douglass's daughter, Rosetta. Her father was listed as a boarder. He, or something like him, may return today.

An interesting article appeared in the *Associated Press* in June 2005 (written by Ben Dobbin). A historian had visited the house in 2003, hoping

to document Douglass's time in Rochester. South Carolina transplants, the Dukes family had been there since 1973. They knew nothing about Douglass, but the late Lee Dukes had told his wife that he'd seen a ghost, a well-dressed black man, working at his bedroom desk.

The sightings had started in 1986. "He described a black guy with gray hair, a gray beard and a top hat…always busy with his head down, constantly writing, always flipping pages," his wife recalled. She didn't have much faith in ghosts, but she had an inkling that the great abolitionist had some connection to her house. She showed her nonacademic husband a book on Douglass. "That's him! That's the guy!'" he shouted.

As of 2005, Mrs. Dukes had never experienced Douglass's supernatural presence, and the reason may be a lighthearted conversation with her late husband that meant so much years later. Mrs. Dukes asked her husband when he went into spirit to tell the ghost in their house not to show himself—"Because I'm afraid."

"I'll do that!" he assured her with a laugh. He may be keeping his word.

FLOWER CITY SUFFRAGETTE

Another esteemed nineteenth-century valley leader was Susan Brownell Anthony (1820–1906), born in Adams, Massachusetts, to a Quaker family. This upbringing left a mark.

The nineteenth-century Quakers had their own ideas, some of them progressive in their day and fundamental in ours. They believed in the equality of the human species and were tireless campaigners for the rights of Native Americans, African Americans and women at a time when there was no social pressure to make the display. They also thought that most simple amusements, like toys, games, dancing, and entertainment—in short, the performing arts—were distractions from the spirit, the "inner light," upon which we need a constant focus. But the propensity to stiffen the spine and stand up to a crowd was with them.

Susan's was an energetic and even activist family. Her father, Daniel Anthony, was a cotton manufacturer and antislavery advocate who was pretty loose by Quaker standards. Brother Daniel Read Anthony would end up as an abolitionist publisher in Kansas.

Susan herself was a sharp one, having learned to read and write at age three. It was all the more ironic that, after the family's move to Battenville, New York, a teacher refused to teach long division to six-year-old Susan because of her sex. Her dad promptly enrolled her in a home-schooled group that taught math and more progressive ideas.

By age seventeen, Susan was attending a Quaker boarding school in Philadelphia. It was not a good fit, but she stuck it out until her family was bankrupted by the Panic of 1837. In 1839, the family moved to the promisingly named Hardscrabble (later Center Falls), and Susan started teaching in New Rochelle. She did well, and she soon found herself a headmistress at a Canajoharie academy, but she started a fight for pay equal to that of male teachers.

By her late twenties, Anthony found herself too het up with the system to work in it and moved back to the family farm in Rochester. She was doing some religious questioning, drifting from the Quakers to the Unitarians and eventually away from organized religion. She also stayed busy and politically active. A chance 1851 meeting on a Seneca Falls street could have sealed the deal.

Elizabeth Cady Stanton and Amelia Bloomer had—like Susan—just been kicked out of a men's temperance meeting. They would become inspirational friends. Anthony joined Stanton in organizing the first women's temperance society in America, but she avoided the stage. Self-conscious about her looks, she had a dread of public speaking. But the world needed waking up! That Quaker spine stiffened and stayed that way forty-five years.

A famous public figure, Susan traveled the United States and Europe and gave up to a hundred speeches a year. She tried constantly to link the causes of abolition and women's rights, not always to the joy of her compatriots. She and Stanton were close friends and tireless colleagues for the rest of their long lives. Often in partnership, they wrote, published and spoke. Anthony's personal list of successes is impressive. The Rochester house at 17 Madison Street was her home base. Countless discussions took place on its porch throughout those forty years. There, the marshals came to arrest her—for voting!—in 1872. She died there in 1906. Is it haunted?

We hear of psychic folklore at several sites associated with this legendary firebrand. Not much of it may be evident at 17 Madison Street. We get subdued reports of SPOTUK that may or may not be valid. It seems fairly clear that the tradition about the Susan B. Anthony house does not compare to that of the one in Amityville.

Anthony's birthplace in Adams, Massachusetts, may have no psychic tradition whatsoever, but Northeastern author David Pitkin had some experiences at a later family home in Battenville, New York. (Susan may have lived there from 1826 to 1839.) He took a strange photograph showing a pillar of light, and one of Pitkin's intuitive friends reported strong sensations related to its famous former resident.

Some of the most interesting folkloric rumors concern one of our favorite haunts in the state, the Ontario County Courthouse in Canandaigua. This marvelous, domed building created by two major local architects has been heavily supernaturalized. The original 1858 design of Henry Searle was renovated and expanded in 1908 under the supervision of A.J. Warner. The spot was interesting before that building stood on it, having been the

site of treaties, scandals, earlier buildings and famous trials. It was said that when the judge's gavel came down in June 1873, fining Susan the hefty sum of $100 for voting, another clattering was heard. The scales of the statue of Justice atop the dome had fallen to the ground. Maybe so. And at least one of the flock of apparitions here would surely have to be its spirit suffragette, no? An ABC news team reported psychic effects during a 2001 special commemorating the life and trial of Susan B. Anthony. Perhaps she was back for the spotlight.

A former Buffalo-area ghost hunter, Rick Rowe, is convinced that he had some psychic impressions at Anthony's Rochester house, Mount Hope gravesite and that little park at Susan B. Anthony Square down the street from her home. Pictures on his website (Paranormal and Ghost Society) may show photographic anomalies around the statues of Susan and Frederick Douglass, conferring as if over tea on her porch about the unknown future. No wonder there would be power surrounding these two forms in jocund company. Their ancient, glittering eyes are gay.

HE DOES IT RIGHT

The second of our valley humanitarians to be raised Quaker, William Pryor Letchworth (1823–1910) was born in Brownsville, New York, the fourth of eight children. As a boy, he and his family moved to Sherwood, near Auburn. As a fifteen-year-old, he started as a clerk in a saddlery/hardware outfit. In ten years, he was a partner in a Buffalo firm in the "malleable iron" business. Pratt and Letchworth became so successful that, by his mid-thirties, Letchworth was thinking about a refuge from business and Buffalo. On one of his day trips to the Genesee Valley, he took a look over the Portage Bridge and found his spiritual home base in the valley by the Middle Falls, where Mary Jemison spent most of her life.

This area had impressed some who had been here before him. The Senecas called the spot *Andekagakwa*, "Where the Sun Lingers," as if the eye of heaven might pause in its course just a bit to regard its own craft. It does work miracles in the spray here.

In 1859, Letchworth bought his first piece of land near the Portage Falls. It included an 1828 two-story frame house that he set about renovating. He recruited the landscape artist William Webster for the paths, roadways, bridges, ponds and fountains, his own form of feng shui. The inn/restaurant overlooking the Middle Falls we have today was named by Letchworth *Glen Iris*: "Valley of the Rainbow."

Constant advocates for the fair treatment of Native Americans, the Quakers were the single European group that the Iroquois never distrusted. Maybe influenced by his upbringing, Letchworth expressed here his respect for the Iroquois, creating the council grounds on a bluff above his home and moving the last Genesee Valley Seneca council house to it from Caneadea. He eventually built a museum to hold Native American artifacts, relocated Mary Jemison's grave to the council grounds and raised a statue in her honor. The Seneca honored Letchworth with the name *Haiwayeistah*: "He

Who Does the Right Thing." He made the Senecas as free as anyone else to return to their homeland in the Genesee Valley.

Like Rochester tycoon George Eastman, Letchworth never married. It would be harsh to say that he lived loveless. He seemed to be involved with a lady doctor in the Genesee Valley, and his estate had no shortage of relatives, friends and company. They explored the natural gifts of the glen as they shared the intellectual ones of poetry, literature and art.

Letchworth retired from business in 1871 and might have been expected to enjoy Glen Iris the rest of his days. He would soon find another calling, that of humanity, and another legacy—social reform. Letchworth traveled widely in the United States and Europe to study society's handling of the helpless, including poor children and epileptics. He pushed New York State to create systems of social support and foster care.

By 1898, the cannibal, industry, and its carnivore partner, government— New York citizens know the latter too well—were casting alimentary eyes on Letchworth's land. The "Vampire State" has taken private property many a time. The Genesee River Company was formed to make electricity, and a dam was planned for just south of the Portage Bridge. Even Letchworth's home Glen Iris—which he had planned to leave to an orphanage—was threatened. In 1906, Letchworth surrendered Glen Iris and his thousand acres to the state—but as Letchworth State Park, created in 1907.

Letchworth lived in his beloved valley until his death on December 1, 1910. He chose to be buried at Forest Lawn Cemetery in Buffalo, New York. A bit of the Genesee is with him, a stone slab from the Lower Falls. Would it be any surprise that he returns?

When you talk to park and county historians, you find many who neither solicit, hear nor remember ghost stories. It is not as if the idea is abhorrent; it is simply as interesting to them as pavement is to the editor of this book. They acknowledge the park as a spiritual site at which guests undergo their own vision quests on its overlooks and trails.

If you talk to past and present staff at Glen Iris, the picture of a haunted inn/restaurant becomes clear. Every fork out of place is attributed to Letchworth, the great philanthropist, suddenly coming back a joker. Some believe they see him here, too. There is talk among the more spiritually attuned that there is indeed an august, invisible presence—a spirit— behind every operation of Glen Iris and the immediate grounds. Who are we to tell them it can't be Letchworth? And there is psychic folklore of other sorts about the park.

Rumors of buried treasure gather around points called Gardeau and St. Helena, guarded in each case by "spirits." Some occult force protects

the stores of jewels or gold, and either drives off the treasure-hunters as they near it or hides the treasure. It might surprise the reader to hear how often such folklore is linked to other paranormal subjects in the Genesee Valley and upstate.

Generations of local high schoolers thought the Cascade House—now abandoned—was haunted, though their name for the haunter(s) is not given to us. And don't forget the mysterious White Deer of the Genesee that you can still see here and there in the park, as well as on the east side of Canandaigua Lake in an old military camp. Yes, there's prophecy about them, too. For that, you'll have to ask the Native Americans.

SON OF ROCHESTER

Rochester's greatest man was born in Waterville, New York, twenty miles southwest of Utica. When George Eastman (1854–1932) was five, his father moved the family to Rochester and set about establishing Eastman Commercial College. His father's death and the college's collapse set the family fortunes reeling.

At age fourteen, Eastman dropped out of school and worked to support his mother and sisters, one of whom was handicapped. It was thought no loss to academia, but the system doesn't measure drive. First working as a messenger boy and then an office boy in an insurance company, Eastman studied accounting at night. By nineteen, he was a clerk in the Rochester Savings Bank and was starting to do reasonably well.

When Eastman was twenty-four, he bought a photography kit to bring on a Caribbean vacation. Taking a simple picture was an ordeal in those days. It took a horse to carry the paraphernalia, and Eastman got a flash. Even a modest improvement in the process would set the world on fire. The vacation took a backseat to making "the camera as convenient as the pencil."

Advances were being made, but they were used only by professionals. Using a formula from a British photography journal, Eastman started making his own film. He worked days at the bank and nights in his mother's kitchen. In three years, Eastman had a formula and a machine for mass-producing photographic plates. Adjustments and setbacks followed, but the handheld camera and Eastman's Kodak company progressed. The hitherto elite art of photography was coming to everyone.

One of Eastman's visionary moments was in the new field of advertising. Self-made East Aurora capitalist and community founder Elbert Hubbard may have been "the father of modern advertising," but Eastman had a knack for jingles. A year after he introduced the Kodak camera, "You press the button, we do the rest" was a national slogan. The Kodak banner, the "Kodak Girl," the Kodak name, Kodak displays

at world expositions—all of these helped build brand identification. Even the name Kodak was an Eastman invention, out of a favored consonant and thin air. It means nothing.

Eastman was more than an inventor, a capitalist or a marketer, however. His social philosophy was ahead of his time. Instead of exploiting workers, he involved them. He became titanically wealthy, but he gave much of what he had back, to his employees and then to the rest of the world: hospitals, dental clinics, medical colleges, music and art schools. In a book about ghosts, it would be pointless to itemize.

The man, though, was shy and retiring. One would think there would be a few more shots of the founder of popular photography. Eastman could walk without being recognized in any Rochester neighborhood but his own.

A hardening of the cells in the lower spine disabled and frustrated this dynamo. In March 1932, at age seventy-seven, Eastman put his affairs in order and shot himself in his own house. His note was cryptic: "To my friends: My work is done. Why wait?" This man who had succeeded with everything else made a hash of his death and died agonized and alone.

Eastman's gifts to Rochester are proverbial, but we shouldn't think of him as its father. Ebenezer Allan, Nathaniel Rochester and other early founders saw that Rochester was there before Eastman came along. But this man who did so much for the Flower City has to be something familial—shall we say, the favored son. Little wonder he might return.

Eastman as a ghost is reported in a couple of places about his treasured city. It may have to do with the nature of folklore, in which famous people come back ghosts more often than the rest of us. Unspecified apparitions and psychic activity are reported about the 1905 George Eastman House, the museum-mansion at 900 East Avenue. In the end, it is attributed to Eastman, but it could just be a "busy" building. This Georgian frame on its urban estate is a likely one for capturing imagination. Other sites designed by J. Foster Warner and the firm of McKim, Mead and White attract stories. Eastman's apparition may appear in the passage under the building through which he could have covertly visited the home of a neighbor. Then there is that hint of an intrigue between Eastman and a secretary.

The Eastman Theater at Main and Gibbs Streets is another site that, since its 1922 opening, has passed psychic rumors along for generations. Music students who walk the long tunnels to the lower-level practice rooms report invisible co-walkers, noises in empty space and rustling and knocking all around them. Workers in the upper levels say much the same. Traditional ghosts at this building, which is now run by the University of Rochester's Eastman School of Music, include "Catherine," a woman

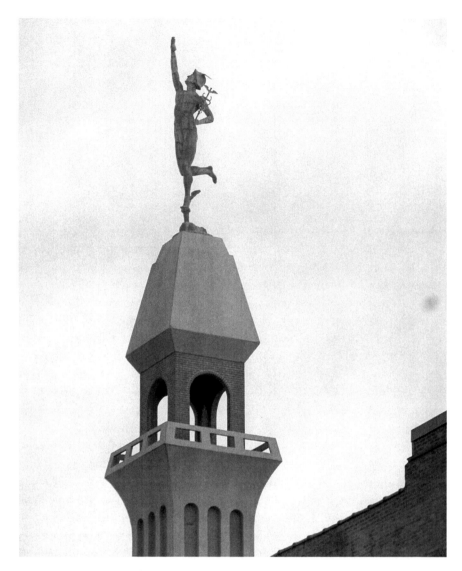

Rochester's famous Mercury Statue presides over its historic skyline.

in white reputed to be a girl who threw herself off the balcony. Eastman himself has been reported, often in his favorite seat—number forty-eight.

The former Eastman family home from Waterville is a classic Greek revival building now at the Genesee Country Village and Museum in Mumford, New York. There is a bit of talk that it, too, may be haunted. As for why Rochester's favorite son should have become an after-life gadabout, that is anyone's guess.

THE COLLECTOR

Another of Rochester's great philanthropists was the only child of a family wealthy on both sides. Spaces in her childhood may have been filled with toys and curios, and the splendor of small, crafted objects stayed all her life with Margaret Woodbury Strong (1897–1969).

In 1920, the well-traveled and well-educated Margaret Woodbury married Rochester attorney Homer Strong and settled into life on a seventy-five-acre Brighton estate. While raising her only daughter, Mrs. Strong amused herself with sports, games, gardens and flowers. After her daughter's death in 1946 and her husband's in 1958, Ms. Strong was projected into the rest of life with a good heart, a lonely streak and more money than any one person needs. Her interests became what some have called a compulsion. She was a *collector*, and on a grand scale.

Art and artifacts were on her radar. Rooms and collections themed around high-end national traditions are legendary at today's Strong mansion and estate. But to many, the memorable feature of Mrs. Strong's relentless gathering was her penchant for dolls, dollhouses and simple toys.

Many collectors of Americana are devoted to the objects of everyday life, but usually ones with historic value. Mrs. Strong hoarded contemporary, often mass-produced items. A lot of this becomes valuable—someday and in limited quantities.

People remember Mrs. Strong returning from world journeys with full trainloads of treasures. Her house had to be expanded many times to hold everything she bought. Few could figure it out. By the end, she owned a vast array of what to many was simple junk, including twenty-two thousand dolls and eighty-four thousand bookplates.

A statement about life is detailed in every one of these modest curios, and Mrs. Strong seemed to get it. A year before her death, she gained a state charter for the Margaret Woodbury Strong Museum of Fascination, one that would use her stash to interpret culture and industrialization in the

nineteenth and early twentieth centuries. It was her estate, her philanthropy and her *things*, that, when she left this world, formed the backbone of today's Strong National Museum of Play at Manhattan Square.

This acquisitive streak and the tendency to gather it all in one place has been the subject of folklore before. Wizards, misers and dragons brooding over treasure are fixtures of world legend. The images involved with the Strong collection may top them all.

Dolls and other effigies of human or animal forms tend to attract psychic rumors. Iroquois false face masks, for instance, are objects of enormous respect and supernaturalism. Carousels and carousel horses have their ghost stories. The "voodoo doll" is too familiar an image to need mention, and cursed dolls and toys are figures of the modern fantasy industry. It is no wonder that the current Strong estate in Brighton might get a little folklore now and then.

Mrs. Strong might have been eccentric, but she cared about others and was much loved by her staff. ("She took care of her people," one of them said.) She may have had some dislike of her own image. Photos of her were rare, and this plays into the psychic rumors of the site in the late twentieth century and today. Some who describe apparitions of Mrs. Strong, after her death, could not have seen her likeness any other way. One memorable report even recreates the ghosts of furniture.

One night, in the mid-1970s, a security guard called a caretaker late at night with a concern about his partner. "There's something wrong with _____," he said. "You have to stay with him while I go out on a round." The caretaker came to the guards' office and found one of them ashen faced and barely coherent. While he sat with the man, the other guard went to investigate. Soon he was back, babbling like the first.

"Stay here," said the caretaker. He went out and found nothing amiss. When he returned, the two guards told the same story: They had seen something uncanny in a side building called the Japanese Pagoda. A former greenhouse and enclosed porch, it had held a surreal scene. Like a vision from the eternal daylight of the Celtic fairyland, this interior space was lit as if by faint sunshine in its own tract of reality. It was perfectly decked out with Japanese art and objects, all spectral. In the center sat a tall woman in her wedding dress, not as happy as one might hope for a bride. She may even have been mature at that point, and had decided to wear her wedding dress just for a while—privately. She looked like she was getting a moment of meditation before the onslaught of life, or a refuge from it. It was thought to be the image of Mrs. Strong, and a moment in time from decades before.

While we can't deny the shock of psychic experience, it does shock us that two grown men would be so terrified of a nonhostile sighting, almost certainly a simple scene from an earlier decade spontaneously recreated. Maybe it had happened many times before when no one was around to see it. Still, this is far from the only report of Mrs. Strong's image or other psychic phenomena about the glorious site of her former home.

It is hard to project the psychology of someone you have never met. The processes of this rich and bereaved woman are beyond comprehension. It may say something that anyone would plunge into the inert world of the toy, of modest effigies that carry such tales about daily life from which, perhaps, their collector felt too far away to ever know.

ABOUT THE AUTHORS

Mason Winfield is the founder of Haunted History Ghost Walks Inc. Author, researcher and "supernatural historian," Winfield studied English and classics at Denison University, earned a master's degree in British literature at Boston College and studied poetry and fiction at SUNY Buffalo with internationally recognized poet and MacArthur grant recipient Irving Feldman. For thirteen years, he taught English at the Gow School (South Wales, New York). Cultural, historical and architectural preservation are vital issues to Mason, and Haunted History Ghost Walks Inc. is proud to support those causes through its partnerships with local organizations.

John Koerner is the author of *The Mysteries of Father Baker* (Western New York Wares, 2005) and *Supernatural Power* (Authorhouse, 2007). He has a master's degree in American history from the State University of New York, College at Brockport. His writing has appeared in the *Hamburg Sun*, the *Springville Journal* and the *Next Step* magazine. Born in Buffalo, New York, Koerner is also an accomplished historical tour guide. He has worked as an instructional guide for Rochester's Neighborhood of the Arts, Roam Buffalo and as a founding member of Haunted History Ghost Walks, Western New York's leading paranormal research organization. Together with his wife, Tammy, he co-founded and co-directed the Buffalo Literary Walking Tours. Koerner is also a social sciences professor at Niagara County Community College, Genesee Community College and Erie Community College.

ABOUT THE AUTHORS

Ordained Spiritualist minister *Timothy Shaw* is a medium, Reiki healer (master/teacher level), metaphysical instructor, writer and lecturer. Reverend Tim received training at the Omega Holistic Institute, the Lily Dale Spiritualist Camp, the Morris Pratt Institute and through the National Association of Spiritualist Churches. Tim's articles have been published in *Wilderness Way* magazine and *Haunted Times*. An independent paranormal investigator, a student of Native American spirituality and a specialist in Spiritualist history, Reverend Tim contributed to this book in many unique ways. When not actively researching, writing, teaching or out on a case, Tim shares his Cheektowaga, New York, home with his wife Nancy-Ann and a Labrador retriever named Ebony. His partnership with Haunted History Ghost Walks Inc. is just beginning.

Born and raised in Orchard Park, New York, *Rob Lockhart* started on his quest as a high school thrill seeker. Rob soon discovered his reverence for small-town history and folklore and started doing research for Haunted History Ghost Walks Inc. in 2004. A fine tour guide and a popular lecturer, Rob has become the expert on Western New York's most legendary cemetery, the mysterious Goodleberg in the town of Wales. Rob plans on preserving small-town America's paranormal secrets until there are no more to tell. He now lives in a delightfully old home in Colden, New York, with his wife, Amber.